THE
RULES
OF
PHOTOGRAPHY

AND
WHEN TO
BREAK THEM

First published in the UK in 2012 by

I L E X

210 High Street
Lewes
East Sussex BN7 2NS
www.ilex-press.com

Copyright © 2012 The Ilex Press Limited

Publisher: Alastair Campbell
Associate Publisher: Adam Juniper
Creative Director: James Hollywell
Managing Editor: Natalia Price-Cabrera
Editor: Tara Gallagher
Specialist Editor: Frank Gallaugher
Senior Designer: Kate Haynes
Design: Andrew Milne
Colour Origination: Ivy Press Reprographics

British Library Cataloguing-in-Publication Data
A catalogue record for this book is available from the
British Library.

ISBN: 978-1-908150-58-5

Printed and bound in China
10 9 8 7 6 5 4 3

THE
RULES
OF
PHOTOGRAPHY
AND
WHEN TO
BREAK THEM

HAJE JAN KAMPS

ILEX

Contents

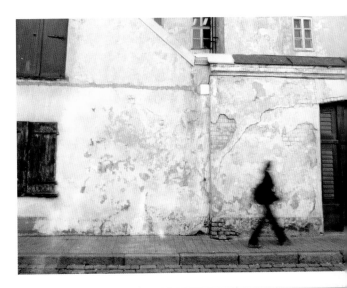

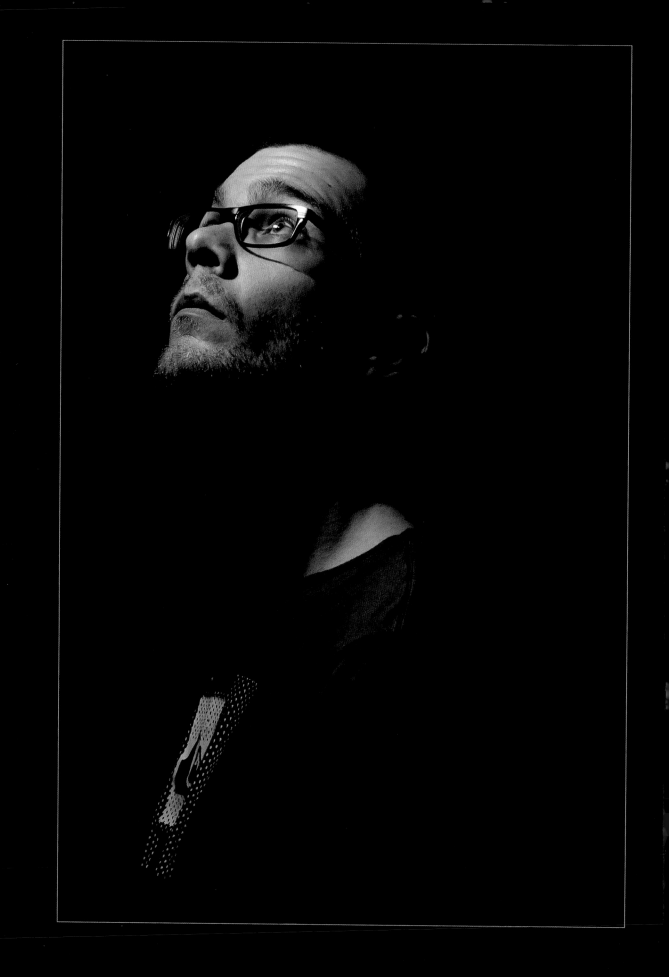

Introduction

When you meet somebody new, you use the knowledge you have about them to form an initial impression. How they dress, how they speak, where you met them, what you already know about them, and what they look like all comes together in your mind to form a stereotype. The stereotype you've created might turn out to be completely wrong, but it still acts as the basis of the impression you make, and is constantly evolving, adjusted by any further interaction. As humans, it's the only way we can cope—we meet hundreds, if not thousands, of people every day, and we simply haven't got the time or mental capacity to evaluate every single person we meet completely from scratch.

Photography is much like that, too. As a photographer, you'll take thousands and thousands of photos. The rules of photography are the stereotypes, the clichés, the shortcuts you can use to help you take fantastic images. For example, if you're taking a photo of a landscape, you keep the horizon straight. If you're taking a photo of a person, you get the eyes in focus. When you're photographing a flower, you try to capture its beauty.

Just as with stereotypes, the rules of photography will only get you so far, but if you have to reinvent the wheel for every single photograph you ever take, you'll spend your entire photographic career wasting your time.

As photographers, we are artists. We're rebels. We're bursting with creativity, ideas, and vision. The rules of photography are building blocks that help us take good photos—and from there, we sprint in our own direction, creating our own style.

Opposite *A classical portrait, perfectly focused, with interesting lighting, that adheres to most of the rules of composition . . . that's the way to do it. Or is it?*

How to use this book

This book has been written with three aims in mind. First off, we'll cover some of the basics of photography and discuss the types of equipment you'll be using. Don't think of this book as a replacement for your camera manual (it's always a good idea to read it, so you know what the features on your camera do), but unlike the dry and factual "button A does this, lever B does that," we'll be talking about how to utilize the gizmos and gadgets at your disposal to create the photos you've always dreamed of.

For our second step (one small step for a photographer, one giant leap for photography . . .) I'll spend some time teaching you the "rules" of photography. It's a little bit like being back in school, I'm afraid, but unless we talk about the basics, we can't climb Mount Creativity. Don't worry, though; it won't be nearly as dull as school.

Without understanding the rules, many new photographers struggle. You might find that you have the technical aptitude to get a shot in focus, for example, but lack the all-important next level of knowledge in order to transform the shot into visual artwork. In short, without an understanding of the rules of photography it is unlikely that your shots will ever evolve from snapshots into art—something people would pay for, display on their walls, or that you'd be able to be truly proud of.

Learning the rules of photography will help you turn your average shots into great ones; however, if you really want to be able to get to the next level, reserved for only a small percentage of snappers, we're going to have to ramp it up a notch: you'll need to learn to recognize when it's a good idea to break the rules. There are situations when bending—or breaking—the rules will make that one shot something worth saving, and maybe it will end up hanging on a gallery wall.

If breaking the rules is so great, why are we bothering with them in this book in the first place? Why learn them at all? As I mentioned,

Above *Shallow depth of field and a typical rule-of-thirds composition help to bring this photograph to life, but by overexposing it slightly (technically known as high-key photography, discussed later on in this book), a touch of innocence is added to the image.*

Opposite *By sticking to the "rules" of photography, you'll find yourself on cruise control toward taking solid, compelling images, like this one. The rules make an excellent foundation for creating the type of photos you want to make.*

Right *As photographers, we have a duty to our viewers. You are meant to entertain, amaze, or amuse. Bore them, and you lose the game. Let's break some rules, and keep things interesting!*

the "rules" exist for a reason. Hundreds of years of artistic output have come to a consensus on certain points. These are ways in which to add more interest to a composition and make it more "viewable" and interesting to an audience.

Finally, you know the expression "think outside the box?" I'll leave you with this thought: unless you know what the box is, you can't consciously decide to think outside of it.

Equipment:
Show me yours, I'll show you mine

You can take photos with any camera; there are beautiful fashion shoots that have been done with nothing more than an iPhone, some lights, and a generous helping of patience.

If you know what you're doing, the equipment that's available to you is probably not going to present any type of stumbling block to your creative success. To get the most control over your photos, you're going to need a camera that has manual controls. That means either a very high-end compact camera, a so-called "bridge" camera (basically, a very big compact camera), an EVIL camera, or an SLR camera.

Compact cameras are models that will more or less fit in your pocket. The majority of digital cameras sold today are compact cameras—but some are more suitable for creative use than others. The important thing you need to check is whether or not your camera has a mode wheel, which enables you to select different shooting modes.

Bridge cameras are essentially very advanced compact cameras that are no longer compact. They generally have all the manual controls you'd expect, but they also have bigger zoom lenses.

EVIL cameras are the half-way house between SLR and compact cameras. EVIL stands for Electronic Viewfinder, Interchangeable Lens (they are also known as MILC—Mirrorless Interchangeable Lens Camera). They are generally a lot smaller than SLR cameras, but accept various accessories and different lenses, which makes them much more flexible and adaptable than bridge or compact cameras.

SLR cameras are the big league; the highest quality sensors and the most versatile controls can be found on SLR cameras, and you can use a large number of different lenses on SLR camera bodies.

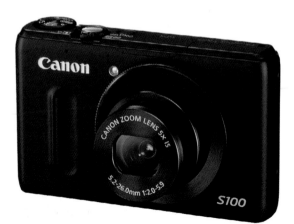

Above *The Canon PowerShot S100 is a high-end compact camera with full manual controls.*

Right *The Nikon P500 is a super-zoom bridge camera.*

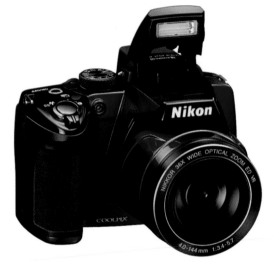

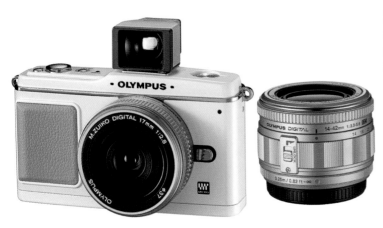

Left *The strengths of EVIL cameras include their small size and their ability to accept interchangeable lenses*

So, what do these cameras have in common? Control. Control over the shutter speed, aperture, ISO levels, white balance, flash, depth-of-field, color, etc. Virtually every aspect that can change the outcome of your shot can be adjusted on one of the cameras we're looking at here. This level of control lets you dictate the terms of your composition, instead of just getting by with what your camera is able to capture.

SLR and EVIL cameras tend to have better sensors than compact cameras, meaning that if you compared a shot taken by a 10 megapixel (MP) camera and compared it to an SLR camera with the same number of megapixels, you would generally find that the SLR/EVIL camera delivered higher image quality.

Overall, SLR/EVIL cameras are faster—faster at turning on, focusing, taking a shot, and taking multiple shots consecutively. SLR/EVIL cameras have higher maximum shutter speeds, which is something that is vital to any type of photography in which you want to freeze movement.

Finally, as SLRs are bigger, they have readily accessible controls. You don't have to work your way through menu levels to change settings as you do with most compacts. SLRs have controls and dials that allow you to change settings quickly.

Above *SLR cameras come in all sorts of shapes and sizes.*

Right *If your camera has one of these—a mode wheel—you've probably got everything you need to implement most of the techniques you'll learn about in this book.*

Equipment:
Choosing a camera

There are many different camera models out there. How do you pick the best one for you? It is really a personal decision, dependent on many factors. Below are a few things to consider.

Price

Start by setting your budget, as this is the most efficient way to cut out the more extravagant cameras. Remember that SLR cameras generally come with a "consumer grade" lens, or without any lenses at all. We'll talk more about lenses later on, but as a rule of thumb, you should budget as much for lenses as for your camera body.

One thing worth bearing in mind is that many new SLR owners start with an affordable, entry-level camera to get used to the basic functions, then upgrade to a more sophisticated model a few years down the line. Choosing a costly, all-the-bells-and-whistles type of camera as your first SLR could prove a frustrating experience, as they generally do not have many automatic functions. More advanced cameras offer less help to the inexperienced photographer.

Size

SLR cameras are bigger and heavier than compact cameras and, in general, the more features they have, the more they weigh. As a rule, the more features your camera has, the more power it uses, so the bigger, better SLRs tend to have larger and heavier battery packs, too. If you don't mind carrying around a heavier camera (plus lenses)

Right *If money is no object, you could easily spend more money on your camera body and a couple of high-end lenses than on the average family car. Canon's EOS 1DX costs around 7000 dollars.*

then this probably won't factor into your decision making much; however, if you plan on traveling with the camera a lot you may want to look for a lighter body.

Resolution

Focusing on how many megapixels your new camera has is not nearly as important as other considerations, unless you are planning on producing your photographs as poster-sized prints. Regardless, even entry-level SLRs are over 10 MP these days, which is plenty for most uses.

Megapixels only factor in when considering the size of print you want. A 6-MP camera can produce prints of up to 11 × 14 inches (27.94 × 35.56 cm), while an 11 MP camera can produce prints of up to 16 × 20 inches (40.64 × 50.8 cm).

The camera resolution is not the only resolution that needs consideration—the LCD display on the back of the camera is important, too. Some entry-level SLR cameras have very low-resolution screens, which can make it difficult to see important details in a photo. The best way to find a model that has what you need is to test out a few cameras first.

Left *SLR cameras can vary in size and weight—from this lithe Olympus E-620 to the Canon EOS 1D X, which is three times heavier.*

Additional Features

Cameras have many extra features available, and which ones you might want will depend on what you are planning to use them for.

Burst Mode allows you to take a burst, or a continuous series of images, which is ideal for action or sports shots. More expensive cameras can take more shots per second, and also have more shots per burst.

High ISO A higher maximum ISO is preferred for night/low-light photography, although it won't help if the higher ISO levels also introduce excessive noise (see pages 24–25).

LCD screen size If you don't like the idea of squinting to see your shot, a larger LCD screen is recommended. Ensure you also compare the resolution of the screens—a bigger screen with lower resolution isn't any better than a smaller screen with higher resolution.

Flash Having an on-board flash is good for beginner SLR photographers who don't want the added expense of external flash just yet.

Image stabilization Some newer SLR bodies have vibration reduction or image-stabilization technology built in—so you will have more success with hand-holding your camera while taking photos with longer exposures. Otherwise, you will need to invest in more advanced lenses to benefit from the same type of technology.

Choosing a new SLR camera can take some time and consideration. Ideally, you want a camera at a price you can afford with good blend of features so you can get a lot of use out of it. There's no need to take out a second mortgage to get a camera that does everything.

Personally, I have been using entry-level camera bodies for years. Most of the photos in this book are taken with a camera body that costs under 650 dollars. As I like to tell people, it's extremely unlikely that your camera is holding you back from taking better photos.

Below *An on-board flash can help you get photos you otherwise couldn't get. However, I have owned several cameras that didn't have a built-in flash, and I have very rarely missed it.*

Above *If your subjects don't move much, you don't have to worry about Burst Mode, high shutter speeds, or similar features. If you're planning to become a sports photographer or capture movement as shown in this image, however, you should take these features into serious consideration.*

Below *Think about what you want to do as a photographer, and use that to guide your camera choice. Just remember that you don't need extravagant equipment to take beautiful shots.*

MEGAPIXELS AREN'T EVERYTHING

A lot of people assume that the more megapixels a camera has the better the images it is capable of capturing. However, this simply isn't true. Camera manufacturers use megapixel count as a marketing tool. A 12-megapixel SLR will produce much better images than a 16-megapixel point-and-shoot camera. This is because the sensor and the individual photosites on the sensor that capture the light from the scene are much larger and therefore more efficient at light gathering—producing cleaner, sharper images with better color and contrast. In short, sensor size is a better indicator of image quality than just megapixel count alone.

Equipment:
Lenses

What makes SLR and EVIL cameras so powerful is their chameleon-like adaptability. The camera body contains the electronics, but the slice of the world you're capturing is determined by the lens you choose for it. A wide-angle lens takes a wide view of the world, while a telephoto lens works much like a pair of binoculars, bringing things at a distance closer to you. The full details of the intricacies of choosing the perfect lens for your needs is well beyond the scope of this book, but let's take a brief look at the kind of features you should be looking for, and some of the basic terms you need to know.

A kit lens is a lens that comes with your camera body. The most common kit lens focal length is one that covers a range of roughly 18–55mm. That gives just the right amount of wide versus zoom to get you started. However, depending on what you are photographing, you may find that the wide-angle is not wide enough, or the telephoto lens you have isn't all it's cracked up to be, at which point it may be time to consider an upgrade.

Another thing worth keeping in mind is that kit lenses are significantly less sharp than more advanced aftermarket lenses. That isn't to say that you can't take beautiful photos with a kit lens, but if you're really pushing for the best quality possible, you're probably best off replacing it with something of better stock.

Wide-angle lenses are designed to "get it all in." They are ideal for capturing wide open scenes, as is often necessary in landscape and architectural photography. These lenses are also ideal for indoor shots where you have less room and want to capture more of the scene. Wide-angle lenses tend to have a focal length of 40mm or wider.

Telephoto lenses are the opposite of wide-angle lenses. They help you isolate a particular subject, and are perfect for photographing portraits, sports, or wild animals. Telephoto lenses are generally 70mm and up.

Above *I've taken a lot of lovely photos with cheap lenses, but there tends to be a direct correlation between how sharp my photos are and the price of the lens. This photo was taken with a Canon f/1.4 lens—one of the sharpest lenses money can buy. Spend as much as you can afford on good glass, and you won't regret it.*

Left *A kit lens like Nikon's 18–55mm is great when you're getting started, but you're unlikely to get the most from your camera body unless you plan to upgrade to a higher-quality lens at some point.*

Right *A 17–35mm lens (like this one from Tokina) is an example of a wide-angle zoom lens.*

A zoom lens is any lens that offers a range of focal lengths. Remember the kit lens we spoke about earlier? That's a zoom lens. Being able to zoom in and out makes a lens more flexible—it helps you take photos of things that are either far away or closer to you—and can be perfect for travel photography, for example. You'll want to take photos of people (so you'll probably zoom in), but you'll also be taking pictures of buildings, landscapes, and so on. The downside of zoom lenses—and especially of lower-quality ones—is that they tend to be less sharp than their non-zoom counterparts.

The opposite of a zoom lens is called a prime lens. These lenses only have a single focal length; they come in wide-angle varieties (such as efl 28mm), "normal" lens varieties (50mm), or telefocus primes (100mm, for example.)

Above *A 70–200mm tele-lens.*

Below *This 10mm lens from Nikon is a prime lens: it only has one focal length.*

Lenses and maximum apertures

The final thing you need to know when it comes to lenses is maximum aperture (the aperture is the hole in the lens through which light can pass). The maximum aperture is a number that's usually printed on the lens. A lens might be 100mm f/2.8, for example. The number you're looking for is the one starting with f/. This describes the largest aperture the lens can give you. We'll discuss later on what the effect of apertures is on your photography, but when selecting a lens, you need to know two things:

• a lens with a larger maximum aperture can give you a smaller depth of field. This is used to blur backgrounds and isolate subjects from the background.
• a lens with a larger maximum aperture performs better in low-light situations, because it can collect more light than a lens with a smaller maximum aperture.

The final thing you'll need to know before selecting a lens is that some zoom lenses have variable maximum apertures. These lenses will be marked with something like f/3.5–5.6. That means that when you're fully zoomed out, your maximum aperture is f/3.5. When you zoom in all the way, your maximum aperture is less; in this case, f/5.6.

EFFECTIVE FOCAL LENGTH

On a full frame camera, a 50mm lens will behave like a 50mm lens, but on a cropped sensor camera the effective focal length (efl) is 50 × 1.5 = 75mm. In other words, to get a wide-angle shot using a 20mm lens on a full-frame camera you'd need a 13mm lens on a 1.5× cropped camera. Conversely, using a 200mm lens on a cropped camera results in an efl of 300mm.

Basic Concepts:
Creating an exposure

When you take a photograph, you (or your camera) are choosing three variables. Together, these variables make up the exposure, or the amount of light that is recorded by the camera. The three variables are shutter speed, aperture, and ISO.

Shutter speed is how long the shutter remains open—imagine you are opening a tap to fill a glass of water. If you open the tap for a long time, you get a lot of water, while if you open it only briefly, you only get a splash.

Aperture is the size of the hole the light passes through inside your lens. If shutter speed is how long you open the shutter for, aperture is how far you open the shutter. A small aperture means that less light reaches the imaging sensor. A large aperture means you'll get a lot of light.

The final variable for exposures is ISO. This doesn't directly affect the amount of light that goes into the camera. Instead, it sets the sensitivity of the imaging sensor. Sensitivity works exactly as you'd expect it: if your sensor is more sensitive (in other words: a higher ISO value), you need less light in order to get the "correct" exposure.

Over the next few pages we take a closer look at each of these concepts in order to see how each of them affect an image.

Right *If you accidentally overexpose your photos, they'll turn out something like this—you will lose a lot of the detail in the highlights. You can reduce the exposure by using a faster shutter speed, a smaller aperture, or a lower ISO value.*

Left *This shot of a flower could have been gorgeous (I know because I got it right in the end), but this shot is badly underexposed. Put simply: it's too dark! You can increase the exposure by using a slower shutter speed, a larger aperture, or a higher ISO value.*

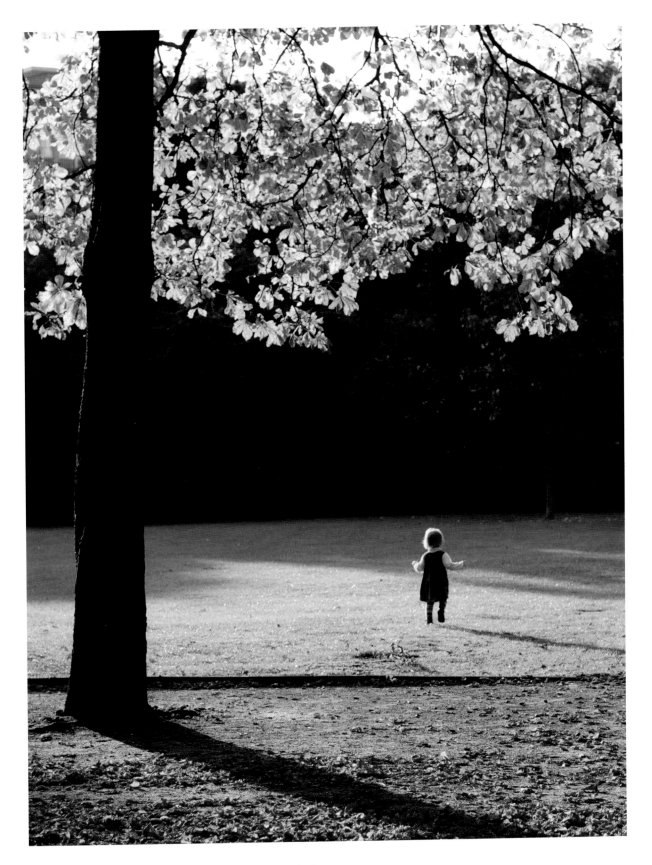

Above *An absolutely perfect exposure adds a lot to the "quality" feel of a photo. In this shot, the grass is quite bright, while the tree trunk is quite dark, but overall, the picture is perfectly exposed.*

Basic Concepts:
Shutter speed

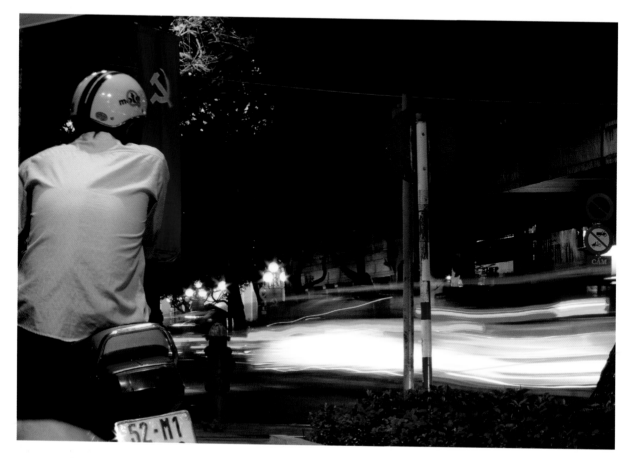

When movement is the name of the game, shutter speed is going to be your best friend. So, which shutter speed is "correct?" Actually, that's a trick question—any shutter speed can be "right," depending on the effect you're aiming for—whether it is to freeze motion, imply motion, blur motion, or simply take a photo of a scene. It also depends on whether the subject or movement is moving toward or away from you, from one side to the other, or not at all.

Shutter speed is measured in seconds, or fractions of seconds. The length of available exposure depends on your camera's settings, and can typically range anywhere from 30 seconds (really slow) to 1/8000 of a second (really fast). The amount of light let in through the shutter is directly proportionate to the amount of time the shutter is opened—so an exposure of 1/500 of a second lets in twice as much light as 1/1000 of a second, and so on.

Above *A slow shutter speed (2.5 seconds) was used for this image. The motorcyclist was sitting perfectly still (that's why he appears not to move), while the traffic rushing past in the background is in motion, so appears as a blur of light.*

When is shutter speed important? When your subject, or any part of your shot, is moving, or when there are issues with getting enough light for a correct exposure. If you are shooting a landscape, a building, or another non-moving object, then the shutter speed is less important, unless you are shooting in low light and need a longer shutter speed in order to get the right exposure.

Right *The feeling of movement and blur in this shot is due to the man moving while the shutter is open. If you want to reduce the blur, use a faster shutter speed—or embrace the cool look, and leave it as it is!*

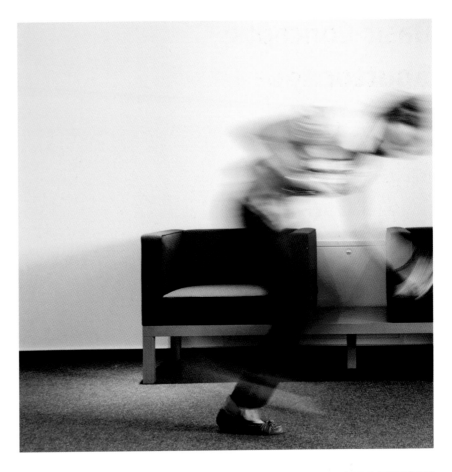

Below *Freezing the motion of a bird in flight requires a fast shutter speed. 1/640 of a second was used for this picture.*

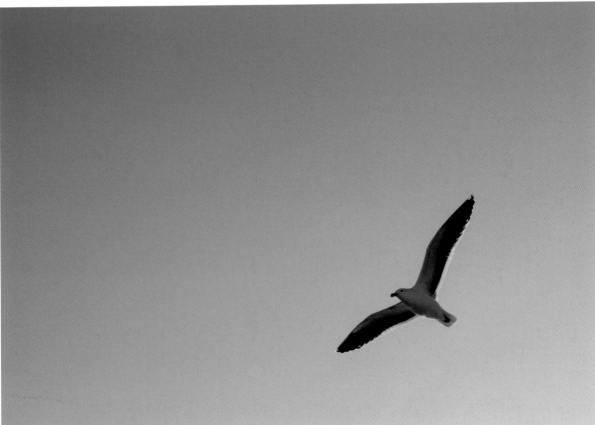

Basic Concepts:
Aperture

The aperture is the variably sized hole in your camera's lens that controls the amount of light that is allowed through it to hit the sensor. A larger aperture enables more light to hit the sensor for the duration of time the shutter is open. Aperture is an important element for getting the correct exposure, but also adds a new twist to your photographs: depth of field.

Aperture is expressed in ƒ/stops (ƒ/1.8, ƒ/5.6, etc.) In order to be confusing, a smaller ƒ/stop number indicates a large aperture. It helps if you remember that the "ƒ" refers to focal length, and

that the number is a fraction of that focal length. You don't have to understand the mathematics; do remember, however, that larger numbers (ƒ/16 and ƒ/22) are smaller apertures, and smaller numbers (ƒ/2.0 or ƒ/3.5) are larger apertures.

So why not let in the most light possible on every shot? The key to using aperture is to understand that different apertures will affect the shot's depth of field—the amount of sharpness in front of and behind the plane of focus (the sharpest part of the photo). There's a lot of physics involved here, but if you remember only one

Below *Using a large aperture (in this case, ƒ/1.4) lets a lot of light into the imaging sensor and gives you a great shallow depth of field. You have to balance this extra light with the shutter speed and ISO (1/500 and ISO 800).*

Opposite *Using a smaller aperture (ƒ/8.0) gets more of the photo in focus, which works much better than the large-aperture photo, in my opinion. To make up for the light that is lost by shooting at ƒ/8.0, I had to use a slower shutter speed (1/13 second), but I kept the same ISO.*

thing, make it this: the larger the aperture, the less depth of field you will get from your photo, meaning that less of your photo will be in focus.

How large or small an aperture you use depends on what you want to get out of a particular shot. Do you want the entire shot to be in focus, from the area just in front of your lens, all the way to the horizon? If so, then you are looking for a smaller aperture, which will let in less light but give you more depth of field. An example of a small aperture would be ƒ/32.

If you want most of the shot to be in focus, such as with landscapes, then a medium aperture can be used—ƒ/11 for example. Finally, if you want only the subject in focus, with everything else in front of and behind it blurred, then you'll likely want to use the largest aperture your lens offers, such as ƒ/4.0 or ƒ/1.8.

Remember one important factor when you begin to adjust aperture: a smaller aperture lets in less light than a larger one, so the smaller the aperture, the longer a shutter speed (or higher ISO level) you are going to need to get the right exposure. We'll talk in more depth about this later on in the book.

APERTURE = SPEED

When photographers talk about "fast" lenses, they are usually referring to the lens' maximum aperture. While aperture doesn't directly affect speed, it does affect the amount of light your camera's sensor is exposed to when taking a shot, and a larger aperture means more light, which therefore means that higher speeds can be used. So if you are looking to take fast shots (action, sports, etc.) then you will likely need a "fast" lens.

TIP

For assistance in selecting the "right" aperture, check if your camera has a Depth-of-Field Preview button, which can help you decide if you need a larger or smaller aperture. You can experiment with aperture by taking the same shot using a variety of aperture settings to see which produces the desired effect.

Basic Concepts:
ISO

ISO is a measurement of your camera sensor's sensitivity to light. The higher your camera's maximum ISO number, the more sensitive it is to light, meaning it (theoretically) should be able to perform better in low-light conditions. Every time you double the ISO number, you double the sensor's sensitivity to light.

So, for example, imagine you are taking photos at ISO 100, but your photos are coming out too dark (underexposed). You can use a larger aperture or a longer shutter speed to let more light in, or you could increase the ISO to 200 and effectively double your camera's sensitivity. Still

not enough? Then increase it to 400 and you have now quadrupled your camera's sensitivity from the original setting. Increasing ISO is an easy way to help your camera achieve the correct exposure, particularly when using fast shutter speeds or in low-light conditions.

Why wouldn't you always use the highest ISO possible? Mainly because the higher the ISO, the more "digital noise" will become visible in your images. This noise can be seen as "artifacts" or small specks appearing in your photo. It is best practice to try to use the lowest ISO possible so your shots are clear and noise-free,

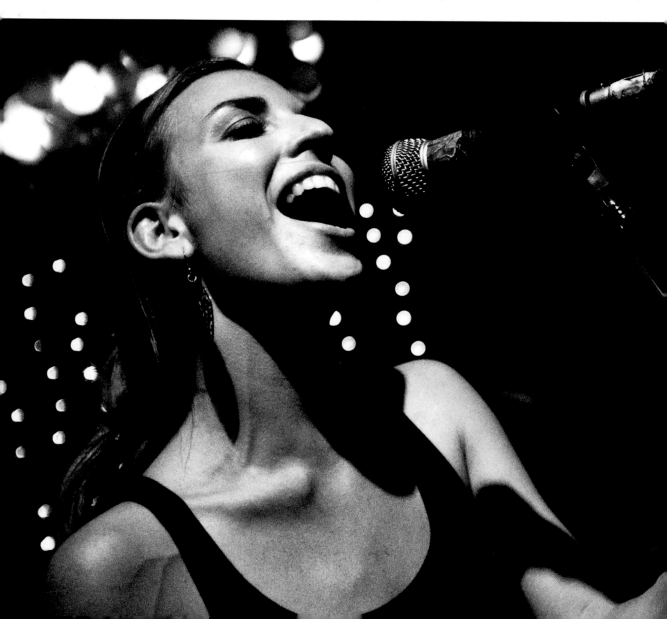

Above *With current-generation cameras, digital noise is hugely reduced. This photo was taken at ISO 1600. Not only is there a lot less noise than in the ISO 4000 photo on the opposite page, the noise that does exist is less intrusive.*

Opposite *This picture was taken with a FujiFilm X100 camera. Despite being captured at ISO 4000, the photo still looks fantastic; it is a testament to how far we have come. Don't be afraid to increase the ISO if you need to!*

OTHER CAUSES OF NOISE

Increasing ISO isn't the only factor that causes noise in a digital photo. Smaller sensors tend to have more noise than larger ones. Longer exposures (a few seconds or more) and bright light sources can also introduce more noise. By understanding what causes noise you can ensure that your photos turn out picture perfect.

unless using a low ISO would mean that your shot is underexposed.

Try using your camera at different ISO settings in various light situations to give you an idea of what your camera is capable of. For example, you may discover that in very dark light your camera is capable of producing relatively low-noise photos at up to ISO 1600, but that you shouldn't try to go above that if at all possible.

Most SLR cameras also come with automatic ISO settings, even when the camera is in manual mode. This means that the camera will boost the ISO level to whichever setting it feels is necessary to achieve the right exposure. This can mean that some photos may use a higher ISO than desired. Consider turning off your auto ISO setting, or find out if your camera can set a cap on how high an ISO level it will use.

Basic Concepts:
White balance

When you look at something that is white, or gray, or any other color, your eye sees the light and your brain interprets the colors. When the light changes (say from daylight to interior light, for example), your eyes automatically adjust so the colors appear the same, even though they are not.

Unfortunately, a camera sensor does not have the same luxury, which is why it uses white balance to ensure that each shot captures the right color temperature. Sadly, whilst your camera is pretty good at estimating white balance, it occasionally gets things wrong—so let's take a look at how light works, and what affects white balance in your images.

All light has a different color—ranging from blues and greens to reds and oranges. Understanding the different colors of light can help you as a photographer to recognize when white-balance adjustments are needed in order to render your shot in the right color, or to adjust the color of the shot to get a better photograph.

Below are listed a few examples of different types of light and their relative color.

Blue sky	Cool, blue
Shade on clear day	Cool, blue/white
Sun on clear day	Warm, orange
Electronic flash	Cool, white
Sunrise/sunset	Warm, red

Below This set shows three examples of white-balancing. The first image is way too cold (too blue), the second photo is more or less correctly balanced, and the last shot is too hot (too warm).

Left *When shooting at the golden hour—at sunset or sunrise—you'll often find your photos come out very warm, but as you can see in this picture, that isn't necessarily a bad thing. If your white balance is off, but it works for your photo, keep it that way.*

Below *Specialist cards, known as gray cards, can be used to get accurate white balance at the time of shooting.*

Each of these types of light can cause issues, depending on what you are shooting. For the most part, when your camera is in auto white-balance mode it will attempt to evaluate the scene to look for neutral (white/gray) objects in order to ascertain the white balance needed in order to make the scene come out correctly. However, it can be a good idea to get used to manually adjusting your white balance, either by selecting a white balance mode or by setting the white balance yourself, as this will give you more control over your composition.

For example, if you are shooting portraits on a clear day you will be dealing with "cool" light, which tends to be a bit harsh on skin tones, even when the correct white balance is used. By manually adjusting the white balance you can help your camera render warmer skin tones, which helps to give your subjects a more natural look. Check your camera's white-balance presets and test the settings—you may find that in most cases these presets can correct common color-temperature issues and help you get a better shot.

To ensure the white balance within a scene is 100% correct you can use gray cards, which let your camera "see" exactly which white-balance settings are required to render the scene effectively. Gray cards are cheap and very easy to use, and should certainly be a part of any serious photographer's equipment. Simply take a shot of the gray card in the middle of the scene you want to photograph (i.e. hold it in front of the lens), then program the camera to use that shot as a white-balance reference. It's a simple and effective way to ensure that the white balance of your shots is correct.

TIP

If you don't want to worry about white balance when you are taking pictures, set your camera to record Raw files. These image files store all the data captured by your camera, which means it is possible to set your white balance on your computer, instead of having to figure it out in the middle of a photo shoot.

Exposure

In Chapter 1, we briefly talked about how there are three elements that determine the exposure of your photographs. In this chapter, I'd like to look at exposure rules in greater detail, and talk about which situations are suited to sticking to the rules—and when you should flout them, of course.

Left *This image has a full range of tones, from the perfect black to the perfect white, with many soft tones in between. A perfect exposure!*

The elements of an exposure

The three things that affect an exposure are speed, aperture, and ISO. Understanding how these elements work together is very important. Without understanding how they interact, it's going to be difficult to progress beyond a certain level in your photography.

You're in luck, though. It's not very hard to grasp an understanding of this three-way relationship (and I'll explain everything in great detail in this chapter) and once you have the basic premise of how these three settings operate it is very easy to work in full or partial manual mode—as long as you have the time to make adjustments and know when to make them.

Above *If you're struggling with the theory of exposure, think of it as a glass being filled with water, as described in the analogy.*

GLASS-OF-WATER ANALOGY

Just to do a quick refresher, and to ensure we understand how exposure really works, let's use something that's easier to understand than light, such as a glass of water.

Aperture The aperture can be described as how far you open the water tap (how much light you let into the camera). Obviously, the further you open the tap, the more water fills the cup.

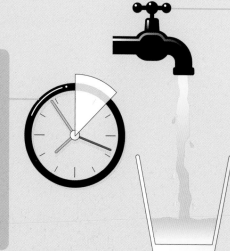

Shutter speed If aperture is how far you open the tap, shutter speed is how long you open the tap for. If you open it for a long time, a lot of water comes out. If you open it only briefly, just a little water comes out.

ISO The final control in our exposure trio is the ISO. From the perspective of our water-glass analogy, ISO could be described as the size of the glass. At a low ISO, the glass is a large one. At a higher ISO, the glass is smaller. In effect, if you are shooting with a high ISO, you need less water to fill the glass.

Equivalent exposures

From the water-glass example, you'll have observed something—if the goal is to fill the water glass, it doesn't really matter how you do it. You can use a trickle of water (i.e. a small aperture) for a very long time, and the glass will eventually be filled. Alternatively, you can open the tap all the way (i.e. use a large aperture) very briefly, and the glass will be filled.

The same is true in photography. Two different exposure settings can result in the same amount of light being recorded inside the camera.

So, when you are taking photos, which setting should you adjust? It all depends on what you are trying to achieve with your shot. Obviously, if you are trying to get the "perfect" depth of field, but need more light, you would select the aperture that best achieves this, and then you or your camera would select the shutter speed or ISO to achieve an accurate exposure (depending on the mode you are using).

TIP: The half/double rule

One easy way to remember the relationship between ISO, shutter speed, and aperture is to keep in mind the half/double rule. This rule states that, in order to maintain the same exposure, if you halve one element (either aperture, shutter speed, or ISO) you need to double the other, and vice versa. For example, if you had a shot set up with a correct exposure of ISO 100, aperture f/5.6, and shutter speed of 1/250, then decided to cut the aperture in half to f/8.0, you would either have to double the shutter speed to 1/125 (i.e. make it two times longer) or increase the ISO to 200 to get the same level of exposure.

Below *If it's motion you want to control (whether you want to freeze it or show it as free-flowing awesomeness), you'll want to control the shutter speed. In this photo, the water looks flowing and fluid due to a 30-second shutter speed.*

Shooting modes

Your camera comes with different shooting modes. These modes are instructions to the camera, and enable you to choose which exposure variables you would like to select yourself, and which ones you'd like the camera to take care of for you.

Depending on which shooting mode you use, you may only have the option to change one or two photographic elements, unless you wish to shoot completely in manual mode. The box below outlines the standard manual and semi-manual shooting modes and how they work.

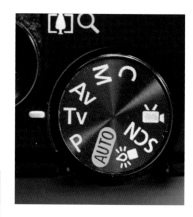

Above *The mode wheel on your camera determines which part of an exposure you control yourself, and which parts you decide to leave to the camera.*

Mode	You Select	Your Camera Adjusts
Manual (M)	Aperture, Shutter, ISO	-
Aperture Priority (A or Av)	Aperture, ISO	Shutter Speed
Shutter Priority (S, T, or Tv)	Shutter Speed, ISO	Aperture
Program (P)	ISO	Aperture/Shutter

Left *Fully automatic modes are great for quick snapshots, or when you don't want to think too much about how your photo fits together.*

In addition to the settings outlined here, most cameras have an "automatic ISO" mode, which you can select in most shooting modes.

The first step towards choosing the "right" shooting mode for a shot is to decide what you primarily want out of your photo. If you are concerned with capturing motion (whether you want the motion to be frozen or fluid) then setting the shutter speed will be your major concern. If you are intending to achieve a particular depth of field, you will want a mode that allows you to control the aperture. For complex shots involving motion and depth of field, you may want to use manual mode as it will give you the most creative control over the shot, although it will likely take more time to adjust your settings to get the correct exposure.

Opposite *For this photo, I wanted to use a shallow depth of field to make the background blurry. Aperture Priority did the trick.*

What is a "correct" exposure?

Above *Due to a weird metering error, my camera thought this was a "correct" exposure. I disagreed, and decided to switch my camera to manual mode instead.*

Below *Because of the sunlight reflected off the icebergs, this photo kept coming out too dark. I had to use manual exposure to get the shot I wanted.*

One common error that new photographers make is trying to keep their camera happy by getting the exposure indicator to "0"—which, of course, makes perfect sense, considering this is the camera's way of indicating that the shot is correctly exposed.

From your camera's perspective, its light meter is always correct—but what the camera perceives as "correct" might not align very well with your creative vision for a photograph. If you are depending completely on your camera's exposure meter, you may be in for a few surprises when you look back on your shots later.

As an example, if you are taking a portrait photo in the shade (under a tree) with a bright background, you've created the perfect conditions for a scene where your camera can become confused. In this setting, your camera wants the light in the scene to be balanced, so it takes into account the background brightness and compensates for it. Unfortunately, that means that your subject turns out very dark. So even though your camera's exposure meter may show a "correct" exposure, if you take a photo with this setting you will not get a good shot.

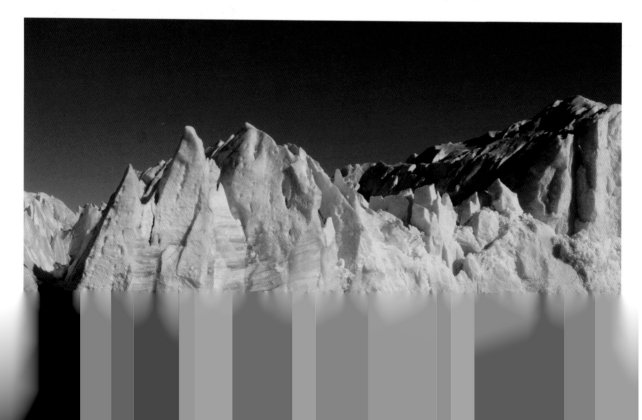

Getting the shot you want

The "correct" exposure is the one that gives you the shot you want. Often, this may mean adjusting or ignoring the "0" exposure, or changing the way your camera measures light during an exposure so that it is more appropriate for the shot—and for your creative vision. In the example discussed previously, where you are taking a portrait in the shade of a tree, you could set your camera's light meter to use spot metering to tell the camera that you want the subject to be correctly exposed, regardless of how it affects the rest of the image. Alternatively, you could use Exposure Compensation to force the camera to overexpose or underexpose. Or you could use fully manual mode to get the exposure you want. We'll discuss all these ways of convincing the camera that it is wrong and you are right.

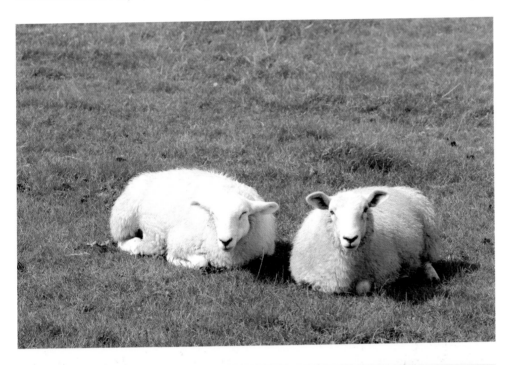

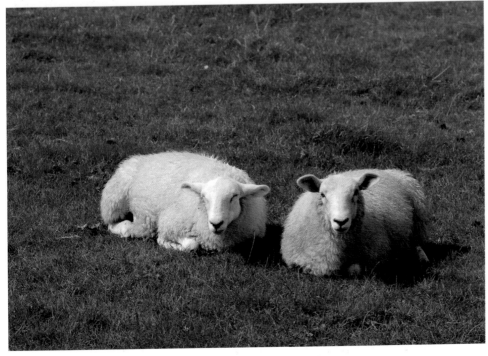

Left *The even color of the background in the top image confused my camera's light meter, but by dialing in a "-2/3 EV" exposure compensation, the lower image came out better. The background may be a little dark, but at least the sheep's wool has all of its detail intact.*

Understanding metering modes

SLR cameras come with several different metering modes in order to help you determine the correct exposure. Different metering programs will work better for different types of compositions or lighting situations, so you may want to spend some time testing them in order to discover the different kinds of results you can get.

Below are the most common metering modes. Note that, depending on the camera make, they may have different names, but will have essentially the same functions.

Matrix Metering is usually the default light-metering mode. It takes into account a "matrix" of the scene in order to determine the best exposure, and get as much of the scene properly exposed as possible. It is ideal for action shots and large scenes with reasonably low contrast (landscapes).

Spot Metering takes a light measurement from only the very center of your focus point. When your subject absolutely has to be exposed properly, regardless of the surroundings, spot metering is the best choice. This mode is only concerned with ensuring that your subject (center auto-focus point) is exposed correctly. Spot metering is perfect for portraits and for macro photography.

Center-weighted Metering is sort of a blend of matrix and spot metering. This mode gives more importance to objects in the center of the frame, but still takes the surrounding scene into account. This mode works well in sunrise/sunset situations, or when there is a large main subject with increased contrast.

One good test to help you become accustomed to your metering modes is to place an object or person in front of a window and take a photo with each metering mode to see the different results.

Below *Matrix metering deals with even relatively complicated lighting situations (like this one) very well, most of the time.*

When you are out taking shots you can also try the different modes to see which ones work best for you, until you are ready to choose the correct exposure yourself.

Above *The stark black background in concert photography can trick your light meter; using spot metering allows you to help your camera figure out what it is you want to expose correctly—in this case, the musician.*

Exposure compensation

Whether you are new to photography or an old hand, you must be ready to make the necessary adjustments in order to get the right exposure if you want to get photos that really pop. Occasionally, this means using exposure compensation to "tell" the camera to under- or overexpose a shot (based on exposure metering). Exposure compensation works in any of the partially automatic modes (Program, Aperture Priority, Shutter Priority), and works by letting the camera measure what it thinks is the "correct" exposure, and then subtracting or adding whatever exposure compensation you've dialed in. Since the way EV (exposure valuation) compensation varies is a little different from camera to camera, we're not going to describe them all—look up "exposure compensation" in your camera manual, and it'll tell you all about it.

Once you get used to exposure modes and exposure compensation it only takes moments to adjust a shot accordingly. Remember that it is much easier to spend a minute or two making changes to the camera to get a correct exposure (one that puts your composition in the best light) than it is to make changes in post-processing.

> **TIP**
>
> *I have found that matrix metering is getting better and better on modern cameras; personally, I never use spot- or center-weighted metering anymore. If my matrix metering doesn't do the trick, I switch to fully manual mode instead. Choose what works best for you.*

Reading a histogram

All this talk about "correct" exposures is well and good, but how do you know whether you have a correct exposure?

A histogram can provide valuable information about the exposure of your shot. Although you shouldn't base your exposure exclusively on the information contained in a histogram, it can provide an excellent guide and indicate where a few corrections might be made.

A histogram consists of a series of columns—usually 256 columns. These represent the 256 levels of brightness that your camera's pixels can fall into. The very first column on the left is pure black, while the column to the far right is pure white. Between the pure white and pure black columns are all the tones your camera is capable of recording. When you see a lot of pixels (a column, or spike) to the far left or far right this can be an indication that there is under- or overexposure.

There are several ways of bringing up a histogram for your photograph. Some cameras can show a "live histogram," which reflects the scene you're pointing your camera at in real-time. Most cameras can show histograms in the Image Review mode (or "Play" mode, as it is called on some cameras). Some cameras show a grayscale histogram, which averages all the colors across the image, whilst others may show three histograms stacked on top of each other, one for each of the primary colors (red, green, and blue).

It's extremely convenient if your camera shows histograms, but it's not the only way to get at this data—you can also show histograms in most post-production software (such as GIMP, Photoshop, Aperture, or Lightroom).

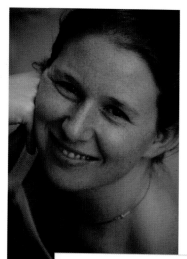

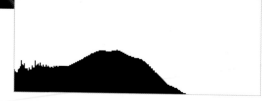

Left In the histogram below, for the picture shown to the left, you can see that most of the data is in the "dark" portion of the histogram (to the left), and there is no data in the highlights section (to the right). This probably means that the photo is underexposed.

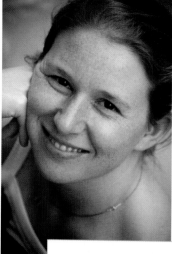

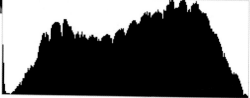

Left By adjusting the exposure of the image you can see how the photo becomes more appealing. Compare the two histograms to get a feeling for how they can help you get the perfect exposure each time.

Left *The highlights in this image are completely blown out, and as expected, the histogram is cut off on the right side, indicating lost data.*

Below *If you are shooting straight into the sun, then overexposure is pretty much unavoidable. In such situations, don't follow your histogram blindly—sometimes, your eyes are better at recognizing what is needed to make a good photo than your camera.*

TIP

The LCD monitor on the back of your camera allows you to check lighting and exposure, but don't trust it to give you an accurate view of exposure, as the display itself is often difficult to see and incorrectly calibrated in the first place. Learn to use your camera's histogram feature to get a true representation of the photos you've been taking.

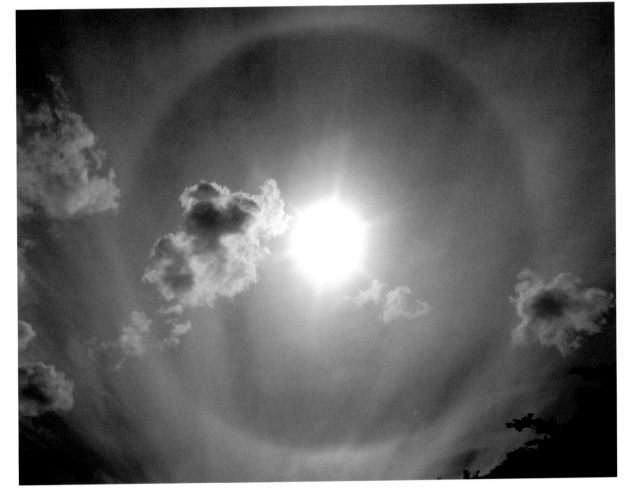

Determining when something is over- or underexposed

Most things in real life are not pure white, so when your histogram shows pixels in the far-right (pure-white) column, this can be an indication that you have blown-out highlights (areas of an image that appear pure white with no detail). As you cannot recover these details in post processing, it is important to readjust the shot to shift everything a small amount to the left by choosing a faster shutter speed, smaller aperture, or lower ISO sensitivity. Overall, you want a nice "mountain" look to your histogram, without too many (or any) pixels in the pure-white column.

The same data found in the histogram also tells us when an image is potentially underexposed. Pixels in the far-left (pure-black) column can indicate "clipping"—where the shadows are so dark that you will not get any detail. Again, you can avoid this by adjusting your exposure to be slightly lighter, which will shift the histogram to the right and give the darkest areas more light.

Relying on histogram information needs to work in tandem to the type of shot you are producing. For example, if you are shooting a low-key composition (see page 48) you will have a significant amount of data towards the black end of the histogram. That would be expected. In a low-key photo, most of the tones will be dark areas and shadows. Likewise, a high-key shot will have data in the white areas of the histogram as it is mostly white and highlights. Adjusting these types of photos based purely on histogram information would defeat the purpose of your shot.

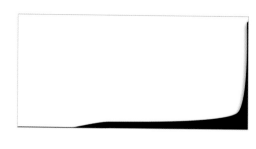

Above *This is what the histogram of an overexposed photo might look like.*

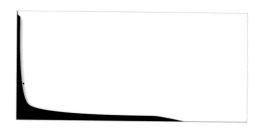

Above *The histogram of a seriously underexposed photo could look a little like this. The big spike on the far left means that you have a lot of pixels that are perfectly black.*

Below *In some photos, a little bit of overexposure is unavoidable. In this shot, the dappled sunlight on the fox is overexposed. Does it ruin the photo? Of course not!*

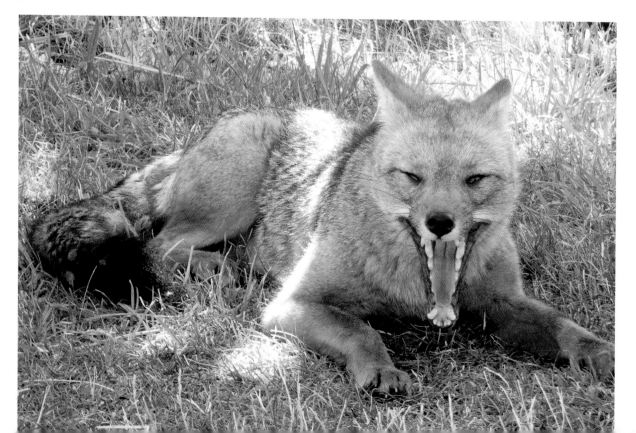

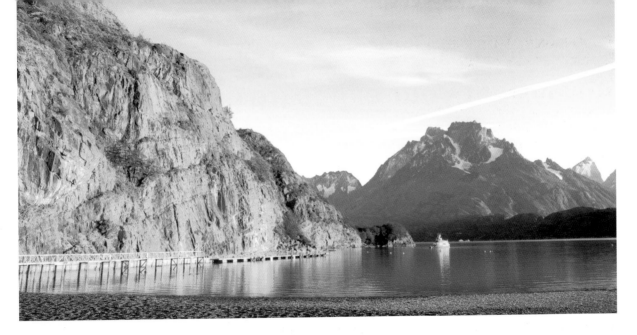

Above *Sometimes, underexposing your photos a little bit can amplify the colors in them. That's particularly true during golden hour, the first hour after sunrise and the last hour before sunset, which is how this mountain ended up looking like it is made of solid gold.*

Left *There's not much in the way of artistic value in this photo, but at least it uses the full dynamic range my camera can muster; everything from perfect black to perfect white is represented.*

Histograms and dynamic range

Histograms are also a good indicator of whether your camera is capturing the most dynamic range possible from the shot. By dynamic range, we mean the range of tones from bright to dark within a photo. A photo with a broad dynamic range will have data in the full spectrum of columns on the histogram, from dark to light. If the photo "falls off" on one end or the other you may need to make an adjustment to the exposure; it could mean that whilst the photo itself isn't under- or overexposed, you're biasing the tones of the photo too far in one direction.

Histograms are a tool that can be used to assist you in deciding how you want to create your exposure. With a little bit of practice in reading histograms, you'll have a great tool under your belt that will help you to ensure your photos come out as perfect as possible.

> **TIP**
>
> *It is very easy to start worrying too much about histograms and exposure and lose sight of what you are actually trying to take photos of. Manual exposure modes and other features are there to help you, but if you find yourself getting bogged down in the technical side of things, take a step back. Photography is meant to be fun, after all, and not an university course in optics and physics!*

Exposure Rule:
Always get your exposure perfect

When people look at your photos in order to give you a critique, one of the first things they'll consider is your exposure. The dreaded phrase "This photo is underexposed" (or "This photo is overexposed") is one of the worst things someone could ever say to me. It implies that I don't know what I'm doing with my photographic equipment.

Cameras have gotten much, much better over the past 20 years, and a large part of the improvement has been in making the measuring equipment and technology built into the camera as close to perfection as possible when it comes to a camera's ability to calculate the correct exposure for a shot. In other words, there's no excuse for over- or underexposing a shot.

There are many good reasons for getting your exposures perfect. A photo with a good exposure just looks . . . right. The majority of photographs you'll come across on the internet, along with just about every shot you'll ever see on television or in the movies, will all fall within the constraints

Above *A perfect exposure goes a long way towards making appealing photographs. This picture is not too bright or too dark, and there is loads of detail in between.*

Below *This photo was recovered after it was underexposed. It doesn't look bad, it just doesn't look "right" either.*

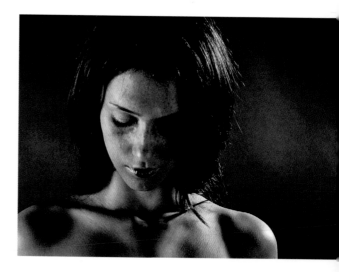

of a correct exposure. Getting your exposure perfect, then, is one of the most basic rules of photography, one that must never, ever be broken.

Granted, it can be a difficult task. Sometimes you may be only provided with the option to underexpose or overexpose a photo and make corrections during post-processing. There are advantages to this approach, as well as some disadvantages.

Why you shouldn't underexpose a photo

When a photo is underexposed, you might find yourself struggling when trying to recover colors if you attempt to lighten it on the computer; this will give you a muddy, washed-out effect. Additionally, the more you brighten a photo, the more chance there is that you will introduce digital noise. This effect is enhanced when you are using a high ISO level, as the shot may already have noise that will be noticeable the more the shot is lightened.

Underexposing is also a problem when parts of the composition end up in the pure black. Pure-black areas cannot have detail recovered, so if you are looking to get more detail out of shadowed areas you will need to let in more light.

Why you shouldn't overexpose a photo

So if it is such a bad idea to underexpose a photo, is it safer to err on the side of caution and overexpose it a little bit instead? It really depends on the situation. When you overexpose a shot you have the option to darken shadows in post-processing, and you won't encounter the noise problem that you do when lightening an underexposed shot. However, correcting an overexposed shot has its own set of challenges.

When your photo is overexposed, the lightest areas may appear much too bright. When the light parts are too bright they lose all detail and cannot be recovered. These areas will appear as pure white, and are often referred to as "blown-out" areas.

To help you avoid over- or underexposure, keep an eye on your histogram; it will let you know if your exposure is too far over/underexposed.

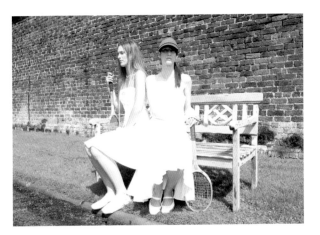

Above *The girls' dresses in this photo are overexposed beyond all rescue.*

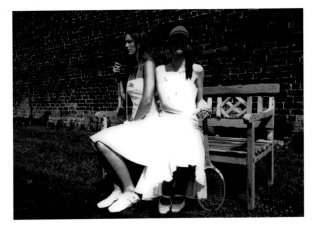

Above *Even by darkening the image way beyond what is useful, we're left with the same big white surfaces: There's no detail there to be recovered, so the photo is ruined.*

WHEN YOU JUST CAN'T WIN

Eventually you will come upon a shot where you have to make a choice—do you aim for correct exposure on the highlights, or try to get details on the shadows? There is no right answer. Given enough time you can always shoot several exposures and hope for the best, but if you (or your subject) are pressed for time the answer is to identify the most vital part of your composition and ensure that it is exposed properly. The rest is just window dressing.

Exposure Rule:
Keep the tones even

Taking photos with a full tonal range (in other words, where there is data in the whole histogram) can be difficult to master. As discussed previously, your camera has a more limited range than the human eye, so the result can be clipped shadows or blown-out highlights (or even both, in some cases) when you attempt to capture a photo. As a result, photographers spend a lot of time trying to even out tones on their photos.

Choosing to photograph scenes with more even tones means that you can usually use automatic exposure modes to get the right exposure. The majority of the time your camera is going to be successful in reading the scene and finding the best exposure for your shot.

TIP

If you're just starting out as a photographer, try to find scenes that have even tones to begin with. Take photos outdoors in overcast weather, for example. This limits the contrast range of your scene, and can help you to capture the photos you want.

Below *Don't think that even tones makes for a dull photo (although many of the photos I've used in this book are black and white to explain the concept). This image, whilst supremely colorful, is also a great example of even tones—nothing is very dark or very bright, and there's a lot of tones in between.*

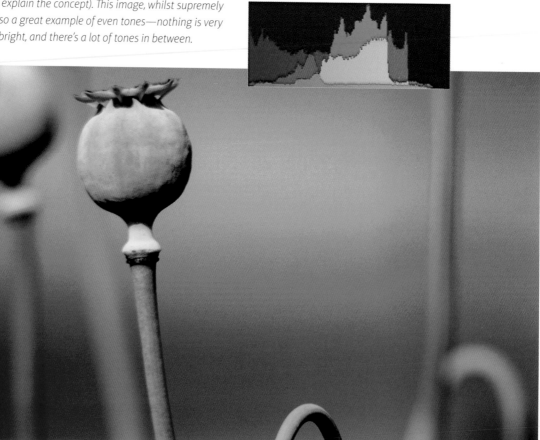

Compositions with even tones make it much easier to get the right exposure, so you will end up with correctly exposed photos while spending less time making camera adjustments to get the right exposure. Ensuring your photos have even tones will help you to avoid the issues of blown-out highlights and clipped shadows, as the range from black to white in evenly toned photographs is much narrower. One good example of evenly toned photography is landscapes shot on an overcast day. The clouds help to diffuse light, so the highlights within a photo are softer, while the shadows are not as dark.

Note that even tones in a photograph does not mean shades of gray, it simply means less dynamic range within a photo. It could mean shooting a blue boat on the ocean, a white bird against an overcast sky, or a forest of evergreens. It could also mean shooting a variety of colors that are all in a similar type of light (such as a field of wildflowers). All you are trying to do is find shots where the entire composition is within a certain tonal range.

Below *My trusty model, Ducky, is showing off a perfect example of even tones.*

WANT MORE DYNAMIC RANGE? CONSIDER HDR

HDR, or high-dynamic range images are a way to avoid the issues found with shots that contain too much dynamic range for the camera to capture. An HDR photo is actually a combination of three or more shots, each at a different exposure. By using different exposures to capture all the shadows, medium tones, and highlights you can capture the entire range of tones in a contrasting scene, and then combine the shots using software to create an HDR photo.

In order to take HDR photos, it's best to shoot in the Raw file format—so be cautious as these images will take up a significant amount of space on your memory card. It is also imperative that each shot be from the same angle with no movement, so a tripod is required. Once you have your shots you will need a good HDR converting program, such as Photomatix.

High-key photography

Sticking to the rules? That was never going to happen in this book, so let's take a look at how we can bend or break the rules of exposure, and end up with photos that still look good.

The simple truth of the matter is that our eyes don't overexpose images; by constantly adjusting their apertures (i.e. the size of our pupils), we always see things more or less "correctly" exposed with our eyes. So we're not used to seeing overexposure, except in photos that have gone wrong. But isn't it often the case that a lucky accident creates some fantastic images? Of course it is!

There are a few different ways in which you can break the rule exposing an image "correctly." Basically, you can either overexpose it (by using too slow a shutter speed, too big an aperture, too high an ISO, or a combination of any or all of those), or underexpose it (by doing the opposite).

Above *This image is from the same photo shoot as the unsuccessful overexposed image (on page 43), but the dramatic composition and contrast between overexposed and not is what makes this photograph work.*

Right *It may be overexposed like there's no tomorrow, but nobody can deny that this is a gorgeous, subtle portrait.*

Now, I'm not in the business of giving people rules for breaking the rules, but in my experience, the best overexposed shots come about when you are able to create a point of interest that draws the eye. Deciding to break one rule doesn't mean you get to break all of them: you still have to find a way to create an image that is appealing. If people aren't connecting with your photo and turning back for a second look, you're getting it wrong.

There's actually a name for photos that are predominantly bright—high-key photographs. This style of photography is bright, white, cheery, and feminine. Well-shot high-key photos exude a feeling of innocence and purity, and the style is often used with glamour and fashion photography.

The trick to great high-key shots is getting a very bright image that does not have a lot of shadows or contrast. In terms of the histogram, you want the details to be over on the right side, while at the same time avoiding too many blown-out highlights. In order to get the bright image you will need some additional light, a white background, and your camera in manual mode. It generally helps if your light setup includes a few sidelights in order to give your subject more of a three-dimensional feel. It also helps if you have some very soft lighting, as hard light will simply create shadows where you don't want them.

Above *This image has too much dark in it to be a high-key portrait—it is, instead, a rather fetching high-contrast portrait that incorporates both blown-out highlights and clipped shadows in the same image. Dramatic stuff!*

Below *There's no reason to leave high-key photography to portraits only; food and other stills photography can look great in high key as well.*

Break the Rule:
Low-key photography

Low-key photography is a style of taking pictures that focuses on producing shots that mostly include dark tones—a person with dark skin against a dark background, or a person in a dark room with only a tiny bit of light on their face, for example. Products are often shot using low-key photography as well, giving a moody, almost menacing feel.

Low-key photographs are excellent for portraying a dark or mysterious mood, and since a lack of light is your primary tool they are pretty easy to set up. The key to achieving a good low-key shot is to aim for extreme contrast. While most of your shot will be dark or fully black, you want part of your subject to be highlighted to draw the viewer's eye. Shooting in black and white can help you get used to identifying and perfecting this contrast, and can help to increase the drama and mood in the photo.

For low-key photographs to work you need to have a significant amount of control over your light source. You can use elaborate studio flash setups, of course, but you don't have to. One method of getting the low-key feel is to place the subject in a dark room, then turn the light on in an adjacent room. Open the door just enough to get the right amount of light on your subject, but not enough to light up the background.

With low-key photography you don't have to worry about clipped shadows, as this is part of the look. Complete blackness around your subject (or even as part of your subject) is perfectly acceptable.

Below *The histogram for this photo is mostly black, but look at it—your eyes are immediately drawn to Ducky's eye.*

Above Low-key photography can create
intriguingly moody portraits like this one.

Exposure Rule:
Always use the lowest ISO possible

With today's technology, it's easy to become impressed by all the bells and whistles offered on digital cameras: vibration reduction, facial recognition, automatic mode selection, etc. One feature often touted by digital cameras as a major benefit is higher available ISO levels, which allows you to increase the sensitivity of your camera's sensor in order to help you correctly expose scenes, particularly in low-light situations.

While it's all well and good that your brand-new camera has an ISO range that goes well into the thousands, it doesn't mean much unless it gives you a good result. Any time you increase the ISO on your camera you are possibly introducing noise to your photo. The higher ISO you choose, the more chance there is that there will be noise, and more of it. Noise is the enemy of good-looking photos so, as a rule, keep your ISO as low as you possibly can.

Below *Even with a compact camera, shooting with a 15-second shutter speed, it's possible to get beautiful, low-noise images by shooting with a low ISO—in this case, ISO 80.*

WATCH OUT FOR AUTOMATIC ISO

SLR cameras are usually preconfigured to automatically select the "right" ISO level according to shooting mode and conditions. Unfortunately, the camera doesn't always make the right choice, leaving you with noisy, high ISO photos that cannot be fixed. You can correct this problem in one of two ways. You can manually choose the ISO level according to the conditions and your preference. Obviously this choice gives you the most control, but also means that it takes longer to set up a shot. Alternatively, limit the ISO level to a specified amount within your camera's menu. For example, if you know that ISO levels of 1600 or lower produce decent shots you can limit the automatic ISO selection to this range. If you need higher ISO you can manually override the automatic selection. You will have to set your camera to record Raw images—but bear in mind that these images will take up a significant amount of space on your memory card.

Be aware that every camera is different; some cameras offer incredible results at higher ISO ranges, while others don't. ISO plays an important factor in being able to get a correct exposure, but if it ruins a photo with noise then it certainly doesn't make your job as a photographer any easier. The trick is to find that balance between higher ISO levels and low noise.

Your best bet is to first find a camera that is able to create reasonably good shots at higher ISO levels, and that meets all your other requirements for a good SLR camera. (Luckily, there are a ton of online resources you can use to research different cameras and their abilities.) This is particularly important if you are planning to do a significant amount of indoor or low-light photography where you will not be able to use flash, as you will have to depend on the ISO boost to give you a good result.

For the remainder of the time, try to use the lowest ISO possible, using the right balance of shutter speed and aperture to give you the correct exposure and capture your composition. ISO sensitivities of 100–200 will give you the best results, and 400–800 will usually be passable but

Above *Some photos would be ruined by even the slightest hint of digital noise—this beautiful and arresting sunrise shot is a prime example.*

noise will start to creep in. Once you go beyond that—and as you start climbing beyond ISO 1600—your results are going to depend heavily on the camera and the shot you are taking.

When to Increase ISO

It is not always going to be possible to use the lowest ISO level, which is why the rule is to use the lowest acceptable ISO. The lowest ISO levels are only possible when you are taking photographs in bright light, using long exposures, and using big apertures (or combinations of the above). Once you start working with lower light levels, faster shutter speeds, or smaller apertures, you need to make a choice—do you increase the ISO levels to compensate or make an adjustment to shutter speed or aperture instead? The answer depends on what you are shooting, and how you want the composition to come out.

Break the Rule:
Shoot at high ISOs

The main reason for shooting with lower ISO is to avoid noise—but what would happen if you crank the ISO right up? Well, you get a lot of noise, obviously. For some photographs, that wouldn't look very good—but in other instances, a generous helping of digital noise can actually make the photo look grittier, more in-your-face, and more genuine.

Noise in digital images is a complicated issue. A lot of noise conjures up images of paparazzi and film noir. You can use this to your advantage by ensuring that your images are improved by noise.

You can use the noise as a feature in your image (i.e. it's an important part of the image), or you can use it as an effect).

Right *This impromptu portrait of my friend Holly was taken in the basement of a pub! By shooting at ISO 800, I was able to make the most of the available light, and the tiny bit of grain present makes the image look better.*

Below *This portrait is almost nothing but noise—but there's something beautifully voyeuristic about this ISO 3200 portrait. The noise seems to amplify the "caught in the moment" feel of this shot.*

3 Composition

Now that we've ticked off the basic rules, it's time to move on to the next part of our program—the more complex rules and ideas that govern our photography world.

Basic rules focus primarily on the technical side of photography—shutter speeds, tripods, etc. The other side of photography is the creative side—and a lot of these choices fall under the umbrella of "composition."

As with the basics, the rules involved with these other aspects of photography are there to help you. Stick to every rule in this book, and we can help you take some solid and creative photos. Once you've established the framework and gotten to grips with taking good photos, it's time to be rebels, break some rules, and take some great pictures.

Left *Every photograph has a "composition"—a series of choices about the "look" of a photo, made by the photographer, that result in a final photograph.*

The rules of composition in photography

Photography is only a couple of hundred years old, but many of the rules of composition have been around for much longer. Many of the rules of composition that photographers use have evolved from the epiphanies experienced by the classical painters. If you have ever taken an art class in your life you will certainly recognize these rules and see how they can be applied to your photos. If not, no worries—they are pretty simple to learn and apply to your compositions.

Your challenge as a photographer is to make an interesting image, which involves introducing a certain dynamic. It's that vibrant quality—the organic part of your photography—that makes your images come alive, and make photographs fun to look at. Good composition encourages and guides the viewer's eye to roam around the picture. These are the images that will have more "staying power," and they will be usually be the more memorable.

LOOKING OUT FOR RULES OF COMPOSITION?

To learn more about the rules of composition, try going to one of your local art galleries that shows the work of classical artists. Compare the paintings you see there with the rules discussed in this chapter, such as the rule of thirds (see pages 94–95)—there will be lots of wonderful examples. Many famous and less famous paintings strictly adhere to the standard rules of composition. An art gallery is also a great place to be on the lookout for how these rules can be broken to great effect, so keep an eye out for the rebels, and think also about how and why their pictures work.

Below *Eyes in focus, rule of thirds, blurry background, capturing your subject "in the moment"—this photograph sticks to many of the rules of composition.*

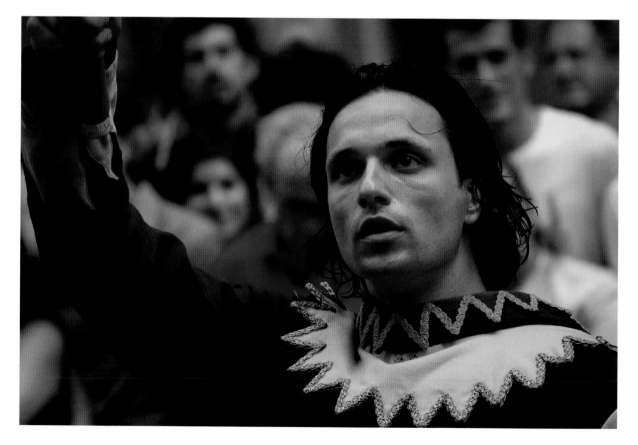

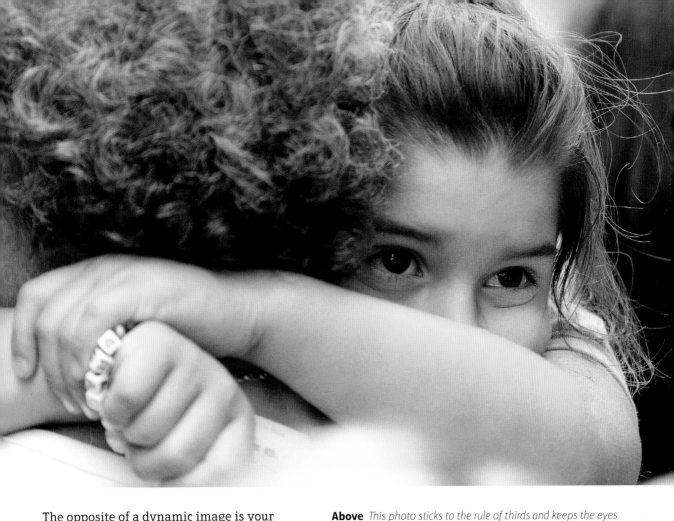

The opposite of a dynamic image is your average, everyday snapshot. Although these may be fine when you want to remember a person, place, or thing, they usually aren't the kind of image you would spend a lot of time looking at, or stick on your walls and call art. How you choose to compose your images depends entirely on your goals as a photographer, of course, but if you have artistic aspirations, it's fair to summarize that your mission as a photographer is to use the rules of composition to create dynamic, memorable images.

Above *This photo sticks to the rule of thirds and keeps the eyes in focus. Far more importantly, however, it tells the story of a daughter who loves her father.*

Below *Even when you get creative with cropping and your aspect ratios, you should still consider the rule of thirds; it is a fantastic way to get powerful photographs.*

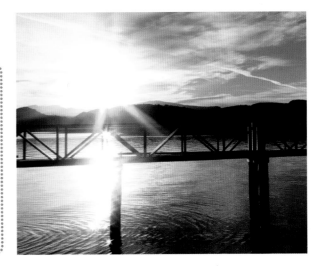

> **TIP**
>
> *A lot of the rules of composition (such as cropping, straightening your horizons and others) can be applied in post-production. Nonetheless, it is a good idea to start thinking about composition already when you are taking the photo—the less you have to edit on the computer, the better your photos will come out.*

The Rule:
You must have a focal point

Have you ever looked at a photograph and thought "what's the point of this?" A common mistake new photographers make is failing to include a natural point of interest in their photos. As a result, the viewer's eye has nothing to rest on, which makes for a dull, ordinary shot. Including a focal point is by far one of the most important rules of photography, so when you are preparing to take a shot, the first thing you should look for is something in the scene that stands out.

Above *There are any number of cool things happening in this photo, but this shot simply includes too much—there's no natural focal point, and as the viewer, you're left hunting around the image with your eyes, wondering what, exactly, the photographer was trying to do.*

Right *This photographer, on her knees in the Blue Mosque in Istanbul, is the only thing that isn't a complete blur in this photo; as such, your eyes are automatically drawn to her.*

WHERE'S THE FOCAL POINT?

It can be difficult for new photographers to compose shots that include a good, effective focal point. Here are a few questions to consider when taking a photo:
- what is the most interesting part of this shot?
- where does the eye want to go?
- what stands out from everything else?
- what is the subject?

While in many cases, you will simply "know" what the primary subject or focal point of your shot is, in ambiguous cases, taking the above questions into account can help to direct your shot.

A focal point is usually a relatively small part of the composition. For example, when taking a portrait shot the eyes will be the focal point, in most cases. Although they take up a small portion of the shot, they command the viewer's attention.

Secondly, there has to be a reasonable amount of contrast between your focal point and the surrounding area, otherwise it won't stand out as a focal point at all. The contrast can be tonal (black/gray/white), color, or even texture. For example, a blue flower in a field of white flowers, a red barn in a field of wheat, a black cat on snow, even a person's eyes in contrast to their face, can all stand out effectively and even dramatically. Contrast helps to bring attention to your focal point, and without it, the viewer's eye won't understand where you want it to go.

The less your subject stands out, the more you are going to have to work to draw the viewer's eye toward the focal point. This is where leading lines (see pages 70–71) can help, as can placing your focal point in the areas that offer the most dynamic tension, using the rule of thirds. Additionally, if you are able to keep your subject in sharp focus while blurring the background, this can help to draw the eye to the subject.

Left *This is a very dark photo, but your eye is automatically drawn to the brightness of the oil lamp—it's a clear focal point.*

Below *Without the bird in the foreground, it would be difficult to find a simple focal point in this shot. The gull gives your eye something to fix on before and after you look at the rest of the photo.*

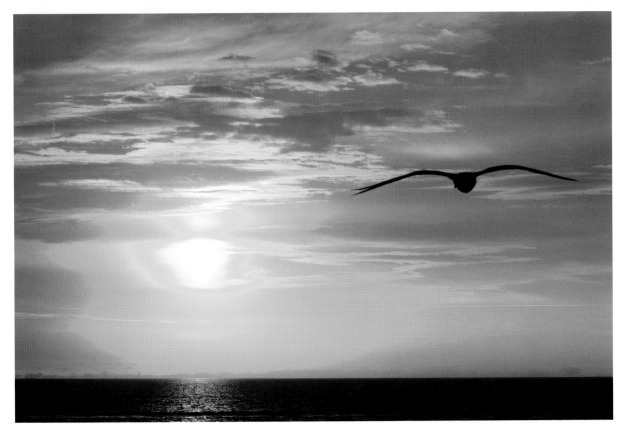

Break the Rule:
Embracing chaos

One type of photography that consistently breaks the rule of using a focal point successfully is seascapes. Long, colorful seascapes with no beginning and no end are gorgeous, and they usually need no focal point. In fact, many of these photos may not work with a focal point, either because there isn't one, or because, by including a focal point, the viewer is distracted and no longer can appreciate just how lovely the shot is as a whole.

Another type of shot that breaks the focal-point rule is one that is filled with any sort of repeating pattern—cracked earth, a pile of leaves, a brick wall. Although these shots are breaking a few other rules of photography too, they can make for interesting pieces.

Obviously, you can't control all aspects of a shot, so if there is no obvious focal point, that shouldn't prevent you from taking the photo, as it may still be good even without a specific point of interest. Sometimes an object, such as a tree or stream, may not appear to stand out when you are looking at the scene, but later will become an obvious focal point.

Left This shot has no natural focal point, but it is a barrage on the senses. It's easy to imagine how having this printed in large format and hung on a white wall would add a huge amount of flair and excitement to the space.

Above This picture of the Grand Canyon, shot from a helicopter, doesn't have much of a focal point, but that's the whole purpose—to illustrate the vastness of the canyon. It's a photo you can get "lost" in—an effect that would have been ruined if you had a natural focal point.

The Rule:
Keep the horizon straight

Creating breathtaking landscapes and ocean scenes is a delightful way to spend some quality time with your camera, and no doubt you will often end up with astonishing results. Use your aperture to control depth of field, and you're on the fast track to producing interesting and compelling photographs. However, there is one incredibly important rule for landscape photography or, in fact, any photography that includes a horizon or line—keep it perfectly straight, always.

If you've ever looked back over old photos you will remember how "off" it feels to gaze upon a composition where the horizon is just slightly canted to one side. Our brains instinctively know that horizons should be straight, so when we see a crooked one it tends to leave us with an uncanny feeling of discomfort. If your goal is to evoke emotions in your audience, chances are that discomfort isn't the feeling you're going for. Perhaps the reason it makes us feel that

Above *Even the slightest hint of the horizon not being straight in this image would kill the magic completely.*

KEEP IT STRAIGHT

The "straight" rule does not just apply to horizons, it effectively applies to any horizontal aspect of a shot—such as the line of a fence, a windowsill, or a road. Any straight line that cuts through your composition—whether it's horizontal or vertical—should be kept straight, otherwise you will encounter the same visual problems as with a horizon.

something is wrong is that we're unconsciously used to aligning our heads with the horizon if we can see one—even if it is in a photograph.

Many people who view photos with tilted horizons end up feeling like everything is going to slide out the lower side of the photo. Some will even go as far as to tilt their heads so the horizon appears straight, without even knowing they are doing it. At a minimum a tilted horizon will draw attention away from your composition, as the viewer's eye will tend to follow the crooked horizon line out of the photograph.

Most photographers are content to simply "eyeball" the horizon to get it reasonably straight while taking the photo, and then deal with corrections during post-processing. However, it is beneficial to get used to using the tools your camera provides to get your shot straight from

the get-go, particularly if you don't want to lose any of the surrounding scene in post-processing.

Many of today's cameras have tools built in to help you. Some have the option to include a "grid" as part of your viewfinder display, so you can use it to line up your composition to ensure that your horizon is straight. The grid function is usually found in the menu settings—check your manual. Other cameras may have a gyroscope built in, and can actually show you exactly how many degrees your horizon is off.

At the less fancy end of the scale, there are also many aftermarket tools you can use, including something as delightfully low-tech as a bubble level to ensure your shots are straight. We'll talk about different ways of straightening a horizon in post-production in Chapter 7.

Right *This photo has two horizons, in effect; the breakers in the foreground, and the mountains raising out of the fog in the distance. Twice the number of horizons, twice as important to get it straight!*

Below *With photos like this, you're facing a difficult choice: do you make the windows straight, or the horizon you can see outside the windows? I tried both, and decided that the window is a "harder" horizon—straightening based on the real horizon made the whole photo unbalanced.*

Break the Rule:
Wonky horizons

With landscapes, if you're looking for a natural-feeling image, escaping the "straight horizon" rule is surprisingly hard—but don't let me dissuade you from trying!

If your composition features a different subject, with the horizon as part of the background, for example, it's less crucial to keep the horizon level. The viewer's eye will be drawn to the subject rather than the horizon. In fact, tilting the horizon can, in certain circumstances, make your composition more interesting as well as add a more interesting leading line towards your subject or focal point.

Tilting the horizon can also create a sense of movement or speed, so when shooting wildlife, boats, or car races, adding a bit of creative tilt can add an additional dynamic interest to the shot. A straight horizon (or other horizontal line) would be dull here—break free from the shackles, and get that camera at an angle!

A composition where the horizon (or road, fence, etc.) is shot on an angle of 30°–60° is referred to as using "Dutch tilt" or "Dutch angle"— and it's a great example of how breaking the rules of photography can add a lot of additional flair to your compositions.

This technique can also work well if you are photographing people—particularly an adult and child. By tilting the camera you can put both subjects on the same level and improve the balance of the composition. Instead of a parent-and-child feel ,your viewer will see the two subjects as equals.

Before you go nuts with tilting horizons in your photos it is a good idea to experiment by taking several shots of the same composition using different angles, including one with a straight horizon. You'll quickly realize that tilting the horizon only works in particular situations, not all of them.

TIP

If you're going to tilt the horizon, make sure you aren't being shy about it. There's no point in tilting the horizon by anything less than 15°; if it looks like it might be an accident, people are likely to perceive it as such—hardly the best way to make a good impression.

Right *One of my more unusual wedding shots, for sure—this photo works better with a wonky horizon because it forces the viewer to look at all three focal points in the image: the sheep, the couple, and the barn in the middle.*

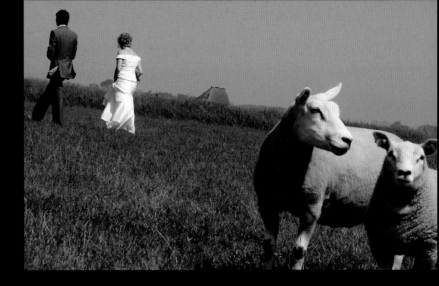

Below *Ocean shots can work well with a Dutch tilt—here, it amplifies the motion of the waves and the feeling of chaos at sea.*

Opposite *If I hold my camera at more of an angle, the photo takes on a new dimension of drama: the wave looks much bigger, and there's a sense of speed. Only if you take a much closer look at the photo do you realize the horizon in the background is at an angle, and that the wave isn't that big at all.*

Right *You can use the "tilted camera" trick to even out people's heights—In this case, the girl is much shorter than the guy. Use the window in the background to see exactly how much the camera is tilted.*

The Rule:

Photograph children at eye level

You know those amazing photographs of children, the ones where you feel as if you know what they're thinking? These are the portraits in which the photographer has really got down to their level in order to give us insight into the world they inhabit. It really works!

As fully grown adults, we're used to seeing children from above. That's not a great way to make a connection. Being above the child is a position of observation and overview. To really tap into the "feel" of a subject, you have to think differently—think as a peer, as an equal. One of the easiest ways in which to achieve that visually when taking a portrait of a child is to get down on your knees.

Opposite top and bottom *Getting down low to capture the glee of children finding a little frog or playing in the garden works wonders.*

Above *By getting down to their level, you have a chance to take portraits of the kids as if they're your equals—it gives a much better balance to your photos than if you take the photos from above. Shot this way, they dominate the frame and showcase their perspective—in this case squinting against the too-bright glare of the sun.*

WHEN TELEPHOTOS ARE HANDY

If you are planning to take lots of candid shots of kids it can be useful to invest in a good telephoto lens. Since most "portrait" lenses involve positioning yourself a few feet from the subject, it can be difficult to get candid shots, as kids tend to ham it up (or turn shy) once they see a camera. With a telephoto lens, you can subtly position yourself several feet away, so the child is less likely to notice the camera.

A photographer who takes portraits of children really needs to make an effort to get to know the child, otherwise the magical connection needed for truly great portraits isn't going to click into place. The first step is to get down to the child's level and see the world through their eyes.

Think of some of those fantastic newborn baby shots—is the photographer hovering over the baby? Nope! He or she is right down there with the child, using the lens as an eye into the baby's personality. An overhead shot would feel completely unnatural here, as it would with most portrait shots.

Photographing children at eye level also gives you more control over composition, meaning it's easier to focus on the eyes and get the child positioned using some of the more advanced composition rules discussed in the next chapter. It is also a more flattering angle for portraits, as it reduces unnatural angles and shadows.

The next time you are photographing children, get ready to get down, and possibly dirty, in order to experience the world through their eyes and help those viewing your photos make a connection with your subject. You will be glad you did, and will quickly notice how much more emotion your photos convey.

Break the Rule:
Climb up high; get down low

There are times when choosing not to photograph children at eye level can make for a more interesting composition.

Eye level is great for many situations, but children are mobile little creatures—they climb on things, crawl under things, and just generally get up to much mayhem. Embrace this fact, and use some of the things you know about differing heights to your benefit. How about a child who can barely stand up being photographed from below with a wide-angle lens, *Reservoir Dogs* style? Brilliant! And a complete reversal of how we normally see children.

From there, you can make all sorts of crazy composition choices. Do the child's parents like throwing the child up into the air? You could try to take those photos at eye-level, but that would require excellent timing and a good trampoline. So embrace the mayhem of "flying" children instead—take photos from below, as they are soaring wildly, with nothing but clouds and sky in the background.

You can also break the rules when you are attempting to introduce a subdued mood to a child's portrait. By shooting "down" to the child you get the parent/child feeling, as if you are giving a lecture or punishment, or consoling a child. Perhaps it's not a common type of composition involving children, but it can certainly convey just as much emotion (albeit a different mood) as an eye-level shot would. As an opposite but equally compelling effect, you can choose to position yourself lower than the child and shoot upward to give the child a sense of authority, importance, or maturity.

Whether or not breaking this rule works depends entirely on what you want the viewer to feel when they look at your composition. Do you want them to feel what the child is feeling? If so, what is the best way to convey those feelings? Getting on the same level as the child gives a window into their world but, sometimes, shooting from above or below can create an equally powerful photograph.

Right The 'seen from below' angle can add oodles of attitude to your shots, which is demonstrated by this sassy portrait.

Opposite For some compositions—like this one, where the little boy was afraid he was going to get yelled at after accidentally tipping over a tray of coffee cups—being ever so slightly higher than the subject helps to tell the story. By taking the photo from above, you allow the viewer to "connect" with the story better.

Below To capture this shot, I overcame my fear of heights and climbed to the top of a climbing frame with the little girl. The sheer joy on her face for being able to climb up faster than I did is clearly visible in this shot.

The Rule:
Use leading lines

Leading lines are a concept that some people find quite difficult to understand, so forgive me if we're taking it a little bit slow!

First off, let me explain that leading lines aren't actual lines in a photograph—they are imaginary lines that your eyes follow around the picture. These lines could be formed of just about anything—a row of trees, a series of cows that happen to be lined up, or a road, stairways, edges of fields, or the horizon. Anything that will lead your eye from one part of an image to the other can be said to be a leading line.

The best way to think of a leading line is as a guide for your viewers. It should point at the subject in your photos, and help your viewers

Above *The girl sitting at the edge of the cliff could easily have vanished in a photo like this—but since the mountains and the edge I'm standing on point to her, your gaze automatically glides along those lines toward her.*

Below *There are many things that are leading your eyes to the cat's—it's the sharpest and best defined part of the photo, but the edges of the box also offer some leading lines—they guide your eyes to the cat's paw and eyes.*

DAPPLE GREY

Above *The musician's arm is an open invitation—and a leading line—inviting you to look at his face*

Right *Leading lines don't come much more obvious than this—all the cables are practically shouting "look at the guy! Look at the guy!"*

realize what they are supposed to be looking at. That may sound a little bit patronizing, perhaps, but trust me—the process will be entirely subconscious, and a photograph with strong leading lines can be very pleasant to look at indeed.

Virtually any line can be a leading line, although some may be more obvious than others. For example, the flow of a dress or the limb of a tree is more of a soft line—gently guiding the viewer's eye towards the focal point. Meanwhile, hard lines like roads, skylines, or horizons provide a more obvious leading line. Photographers can use a combination of hard and soft lines to draw the eye, particularly when there are multiple objects in a shot and the photographer wants to put more emphasis on one of them.

If you are having a difficult time making your focal point stand out, leading lines can help. Common reasons why a focal point is blending into the surroundings is because there is not enough contrast, either in tone, color, or texture, to set it apart. Leading lines can help guide the viewer's eye toward the focal point, where the eye will rest.

With portrait photography you can use the line of a dress, arm, leg, or even the tilt of the body to lead the viewer's eye toward your focal point, which is usually the face or eyes. If you are still finding that your focal point is not obvious enough you may want to try recomposing your shot so there are more leading lines, either by moving the focal point (if possible) or walking around it to find a more suitable background.

Break the Rule:
Peaceful compositions

Sometimes the absence of leading lines will lend itself to a simpler, more powerful composition—for instance, a shot that includes the horizon versus one that doesn't. Setting your focal point against a consistent background of sky or ground, rather than including the horizon, can eliminate distracting elements, so your focal point stands out more.

Similarly, leading lines can add a distracting element to already strong compositions, such as those with significant contrast between the focal point and the background. If leading lines are not needed to strengthen the composition, then leaving them out is just fine.

If you have the option to include leading lines or not include them, ask yourself whether the leading lines improve the overall shot. If the answer is yes, then include them, otherwise it probably is not necessary. Generally, the more elements that are in the shot, the more need there is to use leading lines to help guide the viewer's eye toward the focal point, or to keep them from exiting the shot. Simple shots with only a few elements are less likely to need assistance, as the focal point is much more evident.

Remember that many things can become leading lines, such as the line of a roof, the way a blade of grass bends in the wind, or even the curve of a bird's bill. Completely leaving leading lines out of a shot is near impossible, so your task is to decide whether or not your shot needs to be composed so there are more of them leading toward your focal point.

Below *This shot shows the same girl in the same location as on page 70, but this time without any leading lines. Because your eyes aren't forced in a particular direction, the composition comes across as more peaceful.*

Right *No leading lines, no tricks—just a beautiful, zen-like photograph of a mountain.*

The Rule:
Use unusual viewpoints

Taking the same shot of a landscape, building, person, or pet as everyone else will quickly get dull, mostly because it's all been done before. One of the simplest pieces of photography advice that is fired at all newbies, is to "vary your viewpoints"—especially if you are able to find a truly unusual viewpoint. While this may sound like a lot of hard work, it is well worth the effort and will definitely become easier as time goes by.

Whenever you are preparing to take a photo take a moment to observe your subject and the surroundings. Is there a way in which you can make the composition more interesting? Instead of shooting from the front, could you instead shoot from the side, top, or from underneath? Is there an angle at which you can place your subject next to or near something that will make the composition look better or more striking?

Unusual viewpoints can also involve getting closer to, or getting down to ground level. Pictures of plants, babies, animals, and small objects have much more impact when they are taken with the camera at the same level as the focal point, as they put the viewer on the same page. Meanwhile, pictures of stationary objects taken from above,

Above *Laying down flat on the floor can help to change your perspective—in this case, I loved the idea of the contrasting bright yellow machine and the deep blue sky.*

Below *Getting down low was essential for this shot—this piece of old farm equipment was surrounded by new buildings, and was situated next to a busy road. By placing my camera on the ground and composing the photo using Live View, I was able to exclude the disturbing backgrounds—and get a lovely photo in the process.*

from underneath, or from odd angles can help to add interest to otherwise standard photos.

Once again, it can help to experiment with different angles and perspectives. You can also experiment with taking photos of your focal point "through" other elements—the limbs of trees, a window, a hole in a rock formation. The biggest challenge you'll face as a photographer is to make people stop and take notice of your photos. One of the most effective ways of doing that is to offer them viewpoints they've never seen before.

Above and left *In portraiture, angles can help you tell a story. By taking photos from slightly above or below the subject, you give the picture an emotional cast.*

Above and right *Shooting from above gives a completely different feel to an image—often one of innocence, intimacy, and emotion.*

Break the Rule:
Stick to the classics

Unusual viewpoints can help to add interest and make your photos more dynamic, but at the same time you can't always win. Sometimes an unusual viewpoint can detract attention from your focal point or subject, in which case, it is working against the composition.

The best way to think about composition is to keep the main goal of your photo in mind. You are telling a story—what do you have to do to tell the story well? If your composition is getting in the way of the story, you're doing something wrong.

There are some viewpoints that are used often for a good reason—they work. For headshots, for example, you probably have a pretty standard viewpoint—the model's eyes are level with the camera. The reason for that is simple: it places the subject at the perfect angle and complements everyone's facial features. If you took a portrait or headshot from below or above, the composition

Opposite and above *For portraiture, an eye-level composition is often the best choice, as both these photos demonstrate.*

would not be nearly as effective in creating a beautiful picture.

The next time you are taking a shot ask yourself "Is there a way I can shoot this differently, and will shooting it differently make it more interesting?" If there is, then give it a try. But if you find that a standard viewpoint gives you a solid composition, then you have achieved your purpose.

TIP

Classic compositions may not jump out at you as being artistic masterpieces, but there's definitely something to be said for well-crafted photos following all the rules. Try both, and see what you like best.

The Rule:
Use natural frames

Framing a subject involves using natural elements within the composition to surround the subject or focal point, much like a picture frame surrounds a photo. Adding natural frames to a photo helps to strengthen and improve the composition. Examples of natural frames include arches, buildings, trees, windows, or anything that helps to draw attention to your subject by framing it. A natural frame doesn't have to be on all four sides of the subject, either. One or two sides is typically enough to get the advantages of framing without making the composition look forced.

The purpose of natural frames is to keep the viewer's eye on the photo. As the eye travels to the edge of the composition the "frame" helps

Left *By using natural elements in your scene to frame your photographs, you can create a focus point for your subjects, even in what would otherwise have been a messy scene, like this one.*

Opposite top *Some framing compositions are more elaborate than others. In this case, most of the photo is the frame—but your eyes still drift immediately to the boy.*

Opposite *In some compositions, the frame and the contrast it provides is what makes the picture, as here.*

Below *There's nothing stopping you from using light (or, in this case, darkness) to create the illusion of a frame—the effect is the same.*

to redirect it back toward the focal point, guiding the viewer's gaze, keeping their focus where you, as the photographer, would like it to be. Frames can also be helpful when the lines in the shot lead away from your subject, as the frame will help to redirect the viewer's gaze.

Natural frames don't have to be straight either—all they have to do is keep the viewer's eye inside the photo. Leafy branches, a stream, a bent arm, a wisp of cloud, or even a pile of rubble can serve as a natural frame. Any type of contrast can also serve as a frame by "bouncing" the view back.

Another advantage of frames is to illustrate a sense of depth. By having the frame in the foreground of a photo you offer a chance for the viewer's eye to travel "into" it, which tends to give the image a more three-dimensional feel. Frames can also give the viewer some context of where the photo was taken—indoors versus outdoors, a modern area versus a historical one, for instance.

Break the Rule:
Know when to use frames

Like every rule of photography, natural frames work in many instances to improve your photo—but only if they strengthen the story you are trying to tell. They can be great when seen in isolation, but if you have a whole portfolio of rigidly framed photos, it's not going to work out very well—some photos need some breathing space. A framed photo can make the composition feel closed, and as if you are focusing on a small part of a whole—but it won't give the impression that the subject is part of something larger. For example, if you have a portrait of a lumberjack in a forest with his chainsaw, framing it can give a better focus on the laborer, but you'll lose the sense of how big the forest is. If, instead, you take a step back and have a lot of trees in the image, without framing your subject specifically, you'll get a completely different effect.

Does the frame add drama to the photo? Does it help to tell a story, add context, or give a sense of depth? Does the frame help to illustrate or

Opposite *This photo was taken in an aquarium, but by placing the jellyfish in the photo without any frame or reference points, the illusion that it was taken in the open ocean is quite strong—and makes for a much better photo overall.*

Below *This photo does, in effect, have a frame in it, but the subject is to the right of it. The result is that it looks as if she has "broken free" of the frame, which gives this image a lovely feeling of depth.*

enhance the focal point of the photo? If you can answer no to all of these questions then you may be better off leaving out the frame, as it is not doing anything to improve the composition.

The natural-frames rule is one of the few composition rules of photography that isn't applicable to every single shot you take. While, in many cases, adding a natural frame can improve a composition, many other shots are just as strong without them. It's up to you to decide whether or not adding one will make your shot better.

The Rule:
Always simplify your images

Beginning photographers often make the mistake of trying to do too much, and include too many things in their photographs, resulting in a busy shot that seems to have no real purpose or focus. If you ever have a chance to look at some famous photographs you'll notice that the best shots are often the ones that have the least amount of business—they are all crisp, clean, and simple. Keep "KISS" in the back of your mind: Keep It Super Simple! By making this your mantra you will improve your chances of producing consistently good shots.

The simpler a composition is, the easier it is for the viewer to understand the shot. More importantly, very simple compositions often leave a bit of room in the "story" to let the reader imagine a bit of themselves in the scene. By leaving out part of the story, the viewer can choose to identify with your subjects in a stronger way. For example, when I see portraits

with a foreign power socket in the background, the illusion of the story is broken for me. I know that while I may identify with the subject, I'm subconsciously realizing that it is very far away.

Oftentimes, the easiest way to keep it simple is to zoom in on your subject, effectively cutting out additional objects that may distract from your focal point. When composing the shot, ask yourself what you want to see and cut out everything else. Any object in the frame that is unrelated to the subject, or doesn't add to the composition, should be eliminated if possible.

A second way to keep it simple is to use a large aperture, as this will cut out the distraction of the background and make your subject stand out. However, this can still backfire if the background is particularly colorful or noisy, or if you are unable to use a wide enough aperture to blur the details.

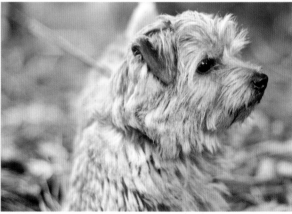

Above, above right, and left *"Less Is More" and "Keep It Simple" are two valuable tenets in photography. There's nothing quite as offputting than an image that is cluttered with too much information. Show only as much as you need to tell the story, and omit everything else.*

TIP

When you are composing a shot, consider whether or not there are elements that can be excluded, and if by excluding these elements you are making your composition stronger and more memorable.

Break the Rule:
Capture complication

There are times when keeping it simple is either not an option, or it just doesn't work for a particular photograph. If you are in a busy, colorful place, your only option may be a chaotic photo. In such instances the photo may still work out just fine, but you have to take a slightly different approach.

Keep in mind that you may have to work harder in a chaotic composition to make your focal point stand out. Yes, you could also choose to break the "focal point" rule at the same time, but you will likely end up with a chaotic photo that is difficult to look at, as the viewer's eye will want something to rest on. In these instances you can always employ an opposite approach by using a dull or boring focal point, which should stand out amongst all the chaos.

It can also be beneficial to leave chaotic or noisy elements in a composition when they help

Above *Sometimes, it's plain impossible to create images with a clean focal point or a "simple" composition—but if the spirit moves you to take photos anyway, go for it. Capture the chaos that's unfolding in front of you!*

to add context to the story behind your photo. For example, if you were taking a picture of a woman shopping for food in a busy street market in New Delhi it would make sense to include all of the people and items around her to convey the sense of chaos she is experiencing. Without the surroundings the photo is simply of a woman, without any clue as to what she is doing or feeling.

Simplicity can create fantastic photos, but at the same time chaos is part of the world in which we live, so it makes sense that sometimes you are going to want to capture its craziness.

The Rule:
Give your subject space to move into

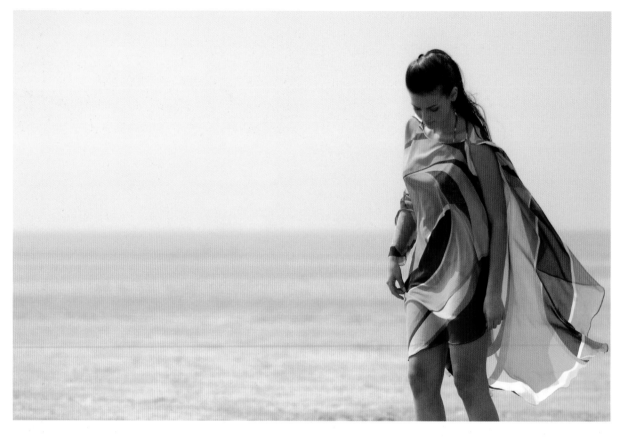

Above *By giving the model space to move into, this composition seems airy and relaxed.*

Below *Using space wrongly makes images unbalanced and uncomfortable. Here, the eye follows the subject's gaze out of the image.*

When I'm planning and executing my shots, I often find that negative space—the space that isn't the main subject—is my ally. You can have a little of it (so, filling the frame with your subject), or you can choose to have an ocean of space surrounding your subject. Both approaches have the same result—a strong focus on your subject—but the context is completely different.

The concept of "having some space to move into" is strongest with portraiture, and the fancy word for the technique is to make use of "active space." The idea is that a viewer will find a photograph more appealing when the subject has room to move into a space in the photograph.

It can be a little counter-intuitive—if you're taking photos, why should you bother thinking about movement? It's a good point, but we are talking about potential movement in this case. It's all about perception. When we look at a photograph of a person, our eyes tend to follow

the face and where it's pointed. If the face is positioned at the edge of the frame looking out, then that's where our eyes go—out of the frame and off to the next photograph. However, if there is active space between the face/eyes and the rest of the photo it feels more natural, meaning the viewer will spend more time looking at the photo.

The same goes for any object that moves: cars, planes, animals, etc. The photo will feel more natural and balanced if there is space for the object to move into, rather than it heading out of the frame. So, wherever your subject appears to be headed try to put more space on that side than the other (or the top, or bottom, etc.).

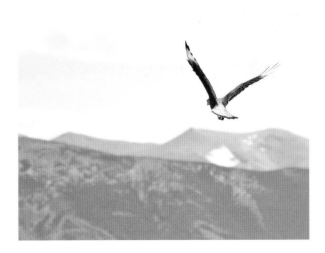

Above *Giving this eagle a "destination" (the mountains in the background) helps to amplify the feeling of freedom and power.*

TIP

Play with the space you have available in your photo to make it balance out better. The best way to find out what works is to compose the photo three times: look at your photo with your subject in the middle, or off to one side of your composition. The composition that sends shivers up your spine is the winner—press the shutter; job done!

Below *This intimate shot uses the rule of thirds to good effect. The subject is facing is to the right of the image, so that's where I decided to give her some space.*

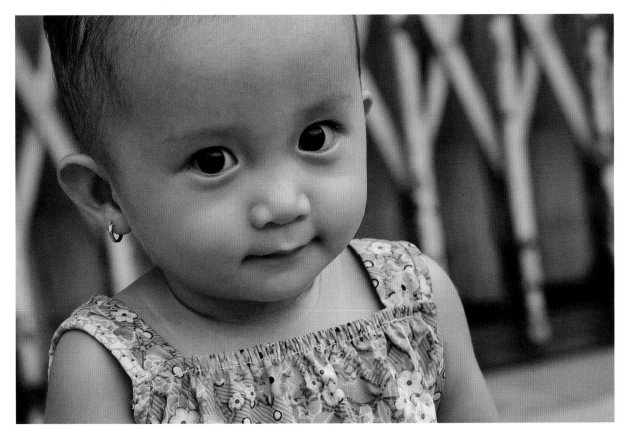

Break the Rule:
"Nearly missed you"

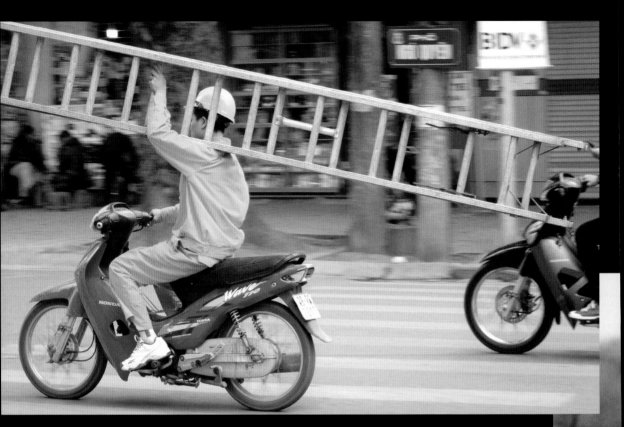

You can tell completely different stories with the same photograph, depending on the use of active space. We've just discussed how your portraits seem more alive when your subjects have a bit of space to move into (see pages 84–85), but what if we do the opposite?

The "nearly missed you" feeling, achieved when you have a subject that is moving out of the frame, can be very strong indeed. It's a nifty little psychological trick: if people are moving out of the frame, we are conditioned (by television, movies, and comic books) to think there's a character leaving the scene. We can use the same effect in photography, and it works especially well with fast-moving objects.

If you have a photo of a runner with a large amount of active space in front of them, you're indicating that they have a long way to go. By reversing the active space, placing a large amount of space behind your subject, you're telling a completely different tale. A runner moving out of the frame seems to be running faster than one

Above *By placing the subject in such a way that they seem to be moving "out" of the photo, you get a dynamic feeling of speed. In this shot it adds to the sense of recklessness of this motorcyclist with his dangerous load.*

Right *Aggressive cropping, a Dutch tilt horizon, and vibrant colors help this image to shout out "speed!"— even though the subject has one foot on the ground and the bike isn't moving at all.*

with lots of space ahead of them in the frame. After all, you nearly missed them with your camera!

Groups of people/subjects are also an exception. If you are shooting a NASCAR race and want to show the pack then obviously you can't put more space in front of the lead car, as this would eliminate most of the other cars behind it. The same goes for schools of fish, flocks of birds, etc. Anytime you are trying to illustrate a group of subjects, the active-space rule becomes less important, as the viewer's eye will most likely be drawn to the group instead of following the lead object out of the frame.

Additionally, anytime you want to see what's behind your subject, active space becomes less important. Examples include the condensation trail of an airplane, a bride's train or the cart a donkey is pulling. All of these secondary subjects help to bring the viewer's eye back into the shot,

so active space isn't as necessary—and it might look a bit strange to cut off the cart behind the donkey, if that's your main subject!

What's Next?

This first set of rules helps you to set some basic parameters as to how to create great shots that people enjoy looking at. But these aren't the only rules. In the next chapter we'll discuss the more advanced rules that help you create stunning compositions to rival some of the photography greats.

In the meantime, get out there with your camera and explore your world through the lens. Practice using these few rules to make your shots better, and you'll be ready to add the rest to your repertoire of skills.

4

Advanced Composition Techniques

If you've given your all to the advice given in Chapter 3, you're probably well on your way to understanding how the rules of photography can be of huge help when it comes to taking better photos. So far, we've mostly covered the basics, which means that we can now graduate to more advanced and high-impact rules, the ones that will take your compositions out of Amateurville, and place them firmly in a penthouse on Professional Avenue.

If it's been a little while since you looked at Chapter 3, it may be a good idea to take another quick look now, because in this chapter, we'll be building on what you've learned before.

Left *The balance of elements in a photo is a crucial part of making conscious composition choices.*

The Rule:
Use plain backgrounds

What's the most important part of your photo? This is not a trick question—the most important part is your *subject*—or what you are taking a photo *of*. As such, why would you include anything in your photo that could distract from that subject?

So, when you're taking photos, keep your background in mind. It's best to shoot portraits or compositions with a single subject against a plain—or at least a single-color—background. A plain, unassuming background will work to highlight your subject and make it stand out. Additionally, ensuring plain surroundings will help the subject of your photo to leap out of the image.

Ideally, you would place your subject against a plain background to begin with, but even if you don't have a perfectly even background available, not all hope is lost. One alternative to a plain background is to ensure that the background is blurred. As you'll remember from the previous chapter, this can be achieved by choosing a wider aperture (smaller number). Even busy backgrounds can be toned down if you are unable to find a plain or single-color background. If you are having difficulty blurring the background on a shot you can try moving your subject further away from the background, and getting closer to them with your camera. The more distance there is, the more the lens will work to make your subject stand out, while making the background blend in.

Below *The plain white background of this shot focuses the eye on what's important: the tasty-looking food!*

Left and below *These photos are taken within seconds of each other, but it isn't hard to see which photo is more visually appealing—the plain background wins every time!*

I know we've mostly mentioned portraits here, but plain backgrounds are a magic bullet for all sorts of photography. They work very well for still-life and product photography. On humans, the eyes are a natural focal point, but in still life, it may not be clear where the photographer wants the audience to look, so use a plain background to really bring home the point. If there's nothing else to look at, your audience doesn't have a choice other than to look at your subject! This is why many photographers employ the use of scrims or screens to provide their subject with plain surroundings. Creating a plain background can be as simple as hanging a sheet or finding a blank, neutral-colored wall to position your subject in front of. All you need to do is to get your subject in front of it and you are set.

Keep in mind that your background does not always have to be white or black. Experiment with taking photos of subjects against a similar color as your main subject—a dark blue cup photographed against a light blue background can look fantastic. The opposite also works: pick a complementary color, and photograph your yellow banana against a bright blue background for extra contrast points.

Just remember that the plain-backgrounds rule simply recommends that the background is not a distracting element in your photo, so usually any solid-colored, lightly textured, or significantly blurred background will work well.

Break the Rule:
Use creative backgrounds

Plain backgrounds help bring your subject to the forefront, but by removing the background, you lose something that can also be important: context.

When the background of a portrait or person-orientated shot helps to tell the story or give more information about a photo, it needs to stay. For example, you wouldn't take a shot of the architect of a new building standing against a plain background; it makes much more sense to put his building in the background to make a visual connection with the viewer and the story

you are trying to tell. However, in these cases it is important to keep the background as uncluttered as possible and only include the elements that pertain directly to the story. For the above example, it would be irrelevant to the photo to have the cars parked next to the building included in the shot, as they have no bearing on the story that the photo is trying to tell.

Taking a studio portrait of a blacksmith might be nifty, but wouldn't it be better to have him around the horses he shoes, the fences he welds, or around the projects he's working on? It would,

Above *For some photographs, the background is the photo—this picture wouldn't have worked at all if it didn't have a background.*

of course, depend on the style of photography you're attempting, but for many photographs, including the background as context is crucial. Again, you should include only enough of the background to provide relevance to the figure of the blacksmith, nothing more: we are looking for context, not clutter.

Sometimes the background, although distracting, is part of the story. Picture riot photos where there is a group of angry, chaotic protestors with a line of calm, professional riot police in the background. You may choose to blur the background police, but they are still a part of your photo's story.

Left *By placing this artist in an urban setting, we're telling a story—if photographed in a studio setting, the effect would have been completely different. The bike helps as well; it helps add context and tell part of the story.*

The Rule:
The rule of thirds

What's the difference between a boring shot and an interesting one? Sometimes it's just a matter of where you place the elements within your composition. The rule of thirds is an incredible shortcut that helps new photographers identify how to create dynamic, interesting shots quickly and easily, simply by adjusting where they put various components in their images.

The rule of thirds states that the key elements of your photo should be arranged in thirds—dividing the scene into thirds both horizontally and vertically. The focal point of your shot should be positioned with two thirds of the scene to one side, and one third to the other, rather than in the middle or close to the edge of the frame.

The point of the rule of thirds is to add more interest to the scene. Placing your subject or focal point in the center makes the image look dead, without movement, vibrancy, or a sense of purpose. It leaves the viewer with nothing to do but look straight ahead at your shot, so they quickly get bored and move on. By placing the focal point (as well as other elements) using the rule of thirds, your shot comes alive and takes on a more dynamic quality. The result is that people will spend more time looking at it—great!

Above *Placing the white flower along the rule-of-thirds axis creates a beautiful, powerful composition.*

Above *The same image with a centered crop isn't nearly as interesting—the eye seems to slide off the little white flower, hunting for something more interesting to look at.*

Below *The rule of thirds is almost magical; any photo utilizing it will have a higher impact than one that doesn't, as this simple composition demonstrates.*

TIP

If you're struggling with getting to grips with the rule of thirds, check whether or not your camera has a Grid Overlay option, which will place the rule-of-thirds lines on your LCD display. If not, stick some see-through tape over your display, and mark the lines with a Sharpie—you'll get the hang of it in no time!

The rule of thirds is applicable to absolutely every form of photography. Use it for landscape shots, for example, or any composition that includes a horizon. You do not want to place the horizon dead center across the middle of your shot, for the same reasons outlined previously, as it makes the shot static and boring. Things in the middle of a photograph are very dull. It's much more interesting to place the horizon in the lower or upper third of the shot.

You can also apply the rule of thirds to portrait shots. Pay attention to where you place the subject's eyes, as in most cases it will be your focal point.

While placing your focal point in a composition using the rule of thirds will certainly make it more dynamic, you can further strengthen the shot by placing other elements in your photo using the same rule. For example, in a landscape shot your horizon appears across the lower third, a barn in the lower-right third, and a bird in the upper-left third. The more you are able to place key elements in your photo using this rule, the more interesting your shot will turn out.

Above *The rule of thirds here is extremely obvious. The shadow that runs down the subject's face and across her shoulder is almost perfectly aligned along the rule-of-thirds lines.*

BUILDING ON THE RULE OF THIRDS

While you can place your focal point at any of the points using the rule of thirds, there is one way to take this rule a bit further. Since most cultures read from left to right this is also the same way they approach a photo. So, it can feel more natural for viewers when a focal point is placed in the lower right third of a photo. Also, if you are shooting a person it is preferable to have more space in the shot on the side they are facing, rather than having them look "out" of the shot.

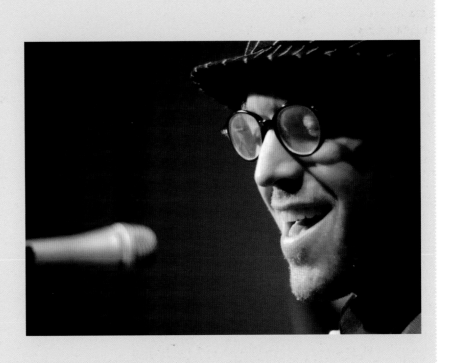

Break the Rule:
Breaking the rule of thirds

Once you've fully explored the rule of thirds and understand how placing elements of your composition using the rule can make your shots more dynamic, you are then are ready to identify when it's okay to break the rule. As discussed, centering a subject often creates a static image, but this may not always be the case. Sure, a centered subject can cause a feeling of unease and of an "unbalanced" photo, but it's possible to use that to your advantage.

Another time where breaking the rule of thirds makes sense is if you are taking a photo of something that is perfectly symmetrical, or something that draws the eye inward. Centering can actually help to fascinate the viewer by pulling them into the image. For example, a long, straight road with large trees framing each side would be a perfect centered image, as you would be giving the feeling that the road carries on forever. The same can be applied to hallways, waterways, or any line that extends straight

Above *Sometimes, your subject speaks loudly for itself. Don't let the rules get in the way of showing off only the parts you like about your photos.*

Below *If one third of your photo isn't very interesting, consider getting rid of it—there was nothing worth looking at at the bottom of this scene, so I decided to include just the interesting parts. Obviously, there's no rule of thirds at play at all here.*

from the front of the photo to the back. One other common photo type that is centered is the pier that leads out to the ocean—if this was placed using the rule of thirds it would likely be less interesting to look at.

Remember that in digital imaging you pretty much always get a "do over" with multiple shots and the ability to copy and crop your photos. If you aren't sure whether a photo would look better centered or composed using the rule of thirds all you need to do is take two shots. You can also experiment with cropping the photo in different ways in post-processing, although you will have more to work with when changing your photos if you take two separate shots instead, each composed differently.

Right *The golden triangle rule principle—where these lines intersect is where to position your focal point.*

Below *Depending on your aspect ratio, the golden triangle rule can supply more extreme and dynamic images than the rule of thirds, as can be seen in this engaging example.*

THE GOLDEN TRIANGLE RULE

Another way of breaking the rule of thirds is by applying another rule instead. The golden triangle rule (which is based on the theory of the "golden mean") is very similar to the rule of thirds, but simply takes the placement of subjects and other objects a tiny bit further. The golden triangle rule is an important guideline for photographers when it comes to placing a focal point or object of interest, as it defines the most dynamic places within a photo. By placing the subject or focal point using the golden rule you will get a more dynamic photo.

Here's how the golden triangle rule works.
Take your photo (or a piece of paper) and draw a diagonal line from one corner to the other (top to bottom, or bottom to top). Now draw a line from the remaining corner so that it meets the diagonal line at an exact 90° angle (see picture, left). Do the same with the other corner. Where the short lines intersect the longer line are where the photo has the most dynamic interest. This is where you should place your focal point.

For example, you could place a person in a shot using the golden triangle rule by having them "lean" into the composition, following the short line created from the bottom corner. Arms, legs, even the eyes placed along this line help to lead the eye into the photo and make it more interesting.

The Rule:
Don't crop heads

Have you ever had someone take a photo of you and a friend, only to find out later that they cut off the tops of your heads? It looks ridiculous, and if someone's head "sticks out" of the composition, your photo is ruined. In other words, it's not hard to imagine where the don't-crop-people's-heads rule came from. When you are working with people and portraits you will soon learn that there are good ways to crop people, and others that are not so good. Cropping heads is at the top of the naughty list. Don't do it!

In the world of portrait photography there are four standard crop types: a head-to-toe crop, a three-quarter crop (from the mid-thigh up), the head-and-shoulders shot, and the head shot. None of these types of crops involve cropping off the top of the head, as it would create a very

Above *There's no excuse for cutting someone's head off—take a close look around the edges of your frame before you take your photo!*

Left *Not a good look…*

Right *If you do have to crop people, try not to crop them on their joints— avoid cutting elbows and knees.*

unnatural-looking image. The only time that photographers ignore these rules altogether is when they are using the person to illustrate something else, such as perspective (placing the subject in the frame to put them in context with something else, such as a mountain or building).

Avoiding cropping heads is particularly important when you are taking group photos, as it will certainly distract from a nice shot as the viewer will wonder why heads were cropped, instead of enjoying the photo. Rather, try to stagger the heads so that no one head is directly above another while ensuring that all remain intact in the photo. If you have to pull back and widen the shot in order to get everyone in, then so be it.

If you do need to crop a photo, the basic rule is to never crop right at a joint—such as knees, elbows, or wrists, as this tends to make the subject appear unnatural or amputated. Instead, go for crop points at the upper arm, waist, upper thigh, or mid-calf. These crop points help you to get a great portrait or person shot without creating an awkward look that makes the viewer wonder what happened to the rest of them.

Break the Rule:
Crop heads & get in close

There is an exception to the don't-crop-people's-heads rule, but it is only relevant when you get in really close. When your composition is focused only on somebody's face, it can improve the shot to crop in close. When the features of the face are the focal point of your composition it is ok to break the rule and crop the top (or bottom/sides) of the head. The reasoning is this—if you're going to get in close, get in really close. When you're filling the frame completely with someone's face, cropping their heads is unavoidable, but it also doesn't look unnatural.

The key is to decide whether your composition is mainly about the body, upper body (shoulders and above), head, or just the face. Each type of shot has a different purpose, and only the face shots will look natural if you decide to crop the head. Otherwise it merely looks like you failed to plan your shot.

Also, if you are going to crop into somebody's head, make sure that you do it properly. A composition where only a thin sliver of someone's head is cut off looks accidental. If you go even closer and cut them off across their forehead, the composition looks a lot more powerful, and at least nobody is left wondering whether or not you did it by accident!

Above *Cropping can bring you closer to your subject, which makes for a more intimate photo.*

Opposite *If you do decide to crop into someone's head, make sure it's obvious that it wasn't done by accident. There's no danger of that in this shot…*

Right *In this image, on the other hand, it's not immediately clear whether or not the crop was intentional or a weird accident.*

The Rule:
Landscapes & maximized depth of field

Working with varying levels of depth of field can be a challenge for new photographers. After all, you may still be making the transition from letting the camera make decisions for you to taking more control yourself. However, controlling depth of field and knowing how much or little depth to use can make the difference between an okay landscape photograph and a great one.

Landscapes are great for drawing viewers into a photograph. They usually include a foreground, middleground, and background. There's usually loads to look at, and the viewer can get lost in a great landscape photo. However, in order to be able to see everything, everything has to be crisply in focus. As such, for landscape photography, using a small aperture—and thereby a large depth of field—is non-negotiable.

The way people tend to look at landscapes is from near to far—so they tend to approach from the bottom of the photograph, viewing the front of the landscape, and then their eyes work

Above *This landscape has a foreground and a background—but by shooting at f/16, I was able to ensure that both were in perfect focus.*

Below *By making the whole photo sharp, this becomes a scene you can easily get lost in—there's so much to look at.*

upward toward the back of the landscape. Having a maximum depth of field allows the viewer to see the landscape as if they were really there, which is an important factor in establishing a connection between the viewer and the photo.

Maximum depth of field does not mean using the largest possible aperture that your lens allows. It means using the appropriate depth of field to keep your entire photo in focus, from front to back. You also want to initially let your camera autofocus approximately one third of the way into the shot and then recompose the shot before you take it. By doing this you are ensuring that you are getting the right amount of focus and proper exposure, without having to use a smaller aperture than necessary. (Remember—a smaller aperture means you need more time for your shot.)

If the light is not particularly bright, or if you need to use a very small aperture, then using a tripod is certainly recommended. Remember that the narrower the aperture, the longer your exposure time needs to be. Using a tripod ensures that there is no movement of the camera, so you can use a long shutter speed and still get sharp photos. With landscapes, as you're photographing objects that remain still much of the time, such as mountains and trees, you don't need a fast shutter speed to freeze movement.

With landscapes especially, you have to remember that great photos are made using a combination of many of the rules of photography.

Above *This glorious vista of mountains and fjords is perfectly sharp all the way from the foreground to the mountains in the distance. It was taken at f/11 with a 17mm lens.*

Incorporate some of the other rules of composition into your landscape shots, as these will help to create more dynamic, visually pleasing photos. Keep your horizons straight, find a focal point, and use the rule of thirds to give the viewer something to focus on. Also, try taking some photos with your camera in portrait orientation; there are so many landscapes out there using the standard horizontal format that this simple trick can really make your picture stand out.

WHICH LENS IS BEST FOR LANDSCAPES?

There is no "perfect" lens for landscape photography, and every photographer has different preferences, but traditionally, landscape photographers will reach for their wide-angle lenses first. It enables you to capture more of the scene in front of you, and wide-angle lenses tend to deliver great results at smaller apertures, too.

Break the Rule:
Landscapes & shallow depth of field

Every now and again, you might find yourself taking a landscape shot in which having everything in focus doesn't really work for some reason. Perhaps you want to focus on a particular subject and make it stand out from the rest of the scene. Once they've mastered taking great landscape shots, a lot of photographers find that the next logical step is to dial back the seemingly iron-clad rule of shooting landscapes with a small aperture, and explore shallow depth of field.

When we were talking about portraiture, we said that a large aperture puts everything in the background out of focus. That's true, but only because we are focusing on a point closer to the camera. There's no law against using a larger aperture and focusing on infinity. This does the opposite; it blurs the foreground and keeps the background in crisp focus, which looks beautiful for some compositions.

It's not all foreground or background either; if you have a telephoto lens and a sufficiently wide aperture, such as $f/4$ or $f/5.6$, you can focus on something in the middleground of a composition and have both the foreground and background blurred, which can create gorgeous and visually interesting shots.

You can have a lot of fun creating dynamic landscape photos without using maximum depth of field. Simply decide on what needs to be in focus and what doesn't. For example, a field of wild flowers with a tree in the middleground may look good using maximum depth of field, but using a larger aperture for a narrower depth of field can make the tree a better focal point by blurring the wild flowers and the sky behind the tree, which gives the shot a more interesting, artistic feel.

For landscapes, it's easy to stick to the "wide depth of field" rule, and it's all too easy to leave your camera at a small aperture. Break the mold and experiment with a variety of apertures—it may just make your landscapes sparkle.

Above *Shallow depth of field helps highlight details, like these footprints, in some landscape shots.*

Right *Using a shallow depth of field in some photos can give the impression of looking "through" the landscape at the main subjects. Here, looking through out-of-focus blades of grass gives this image a voyeuristic feel.*

Below *If you're using framing in your shots, ensuring that the frames are slightly out of focus could help draw your viewer's eye to the background.*

The Rule:

Always get in close

One common, widely touted rule in photography is to fill the frame with your composition. It's a good rule, as it overcomes the way our eyes take in a scene compared with the camera. When you are looking at something, you're able to focus your concentration on only a small part of the scene. Imagine the way you are seeing right now, for example; you are looking at a book or an eBook screen. The letters on this page are only a very small percentage of the entire field of view in front of you, but you are able to "tune out" the rest of the world whilst you are reading.

If you were to take a photograph with a camera that had the same field of view as your eyes, it wouldn't be clear what you wanted your viewers to look at, so in order to "trick" the viewer's attention to go where you want them to look, you have to get in very, very close to your subject. Filling the frame doesn't mean getting only your

subject into the photo; it simply means that you get close enough (or crop later) so that the shot consists of only the elements you want to include. These elements could consist of the subject or focal point, leading lines, natural frames, and so on.

There are a few reasons why this rule works so well, but the most important is that it focuses the viewer's attention. After all, your viewers can't be distracted by something you decided not to include in your photo.

If you have spent a reasonable amount of time looking at other people's photographs, then by now you'll probably have some idea about what this means. Potentially good photographs can easily be ruined by including elements that don't belong in the photo, or that serve to distract attention away from the subject.

Another reason to get in close is to give viewers as much detail as possible. Taking

a photo from far away with a 50mm lens of a scene is going to give you much less detail than the same photo using a 300mm lens, or by moving significantly closer to the scene. This is particularly important with wildlife photography as viewers want to feel as if they are getting up close and personal with the subject, instead of admiring it from afar.

Finally, how much emotional impact do you want your composition to have? Closer, more detailed shots where the subject takes up a good portion of the frame have much more impact than regular shots. By getting in close you can establish a connection with the viewer and have them feel a connection with the subject.

Opposite *By getting closer to the baby elephant, it helps tell the story. Its mother is there to help give a sense of scale, but if I had included the whole mother, I'd have lost the intimate feel of this photo.*

Right *It doesn't matter if you're photographing people, buildings, animals, or landscapes—go as close as you have to; fill the frame with your subject!*

Below and below right *Which one of these shots has the most impact? Obviously the first.*

Break the Rule:
Take a step back

Whether or not the getting-up-close rule we've just been discussing works depends on whether or not the setting of your shot has a bearing on the subject. Picture an up-close shot of a dog. While dog-loving viewers may feel an emotional connection to the animal, the context of the photo may play a part in increasing the interest of the composition.

Suppose the dog was sitting in a landfill—would that change the viewer's feelings about the piece? Likely. What if the subject was a small child? Would there be a significant difference in the emotion felt if you filled up the frame with only a face shot, as opposed to including the surrounding environment? Very likely. In these cases the context provided by the subject's surroundings is just as important as the subject itself, and should be included.

Also important in photography is the idea of scale. If you are trying to illustrate how large (or small) something is then you need to include more of the surroundings in order to establish

Right *In landscapes and urban settings, pulling back can give a full impression of the hustle and bustle that happens in front of you, as it does in this photo.*

Below *Sometimes, portraiture is all about the context. Taking a photo like this means that we've placed the focus on her surroundings instead of on our model—with beautiful results.*

scale. Zooming in on a person standing next to a mountain is great if you only want a shot of a person; however, if you are interested in showing how large the mountain is (or how small the person is in relation to the mountain) then you need to pull back.

Similarly, pulling back can work to give the subject an aura of insignificance. This type of photography is perfect for helping the viewer to connect with the subject emotionally, such as with a small boat lost on the ocean, or a person lost in a crowd. So while zooming in helps to make the subject important and the focus of the composition, pulling back can help to communicate how small we feel in this large world.

The Rule:
Balance the elements of your composition

Above, above left *In this image, the sun is balanced out by the ship in the right-hand side of the image. Without the ship, the photo would look completely lopsided.*

Good art—including photography—is all about balance. First off, let me point out that balance doesn't mean symmetry. I'm not saying that one half of your photograph has to be identical to the other half (i.e. one side identical to the other). Balancing your composition simply means placing elements in your composition to offset each other. Think of your compositions as a conversation—if one side of your photograph asks a question, is there something that can answer the question on the other side?

By balancing the elements in your shots you can create compositions that are fun and interesting to look at, and that can help tell more complicated stories, rather than just shooting whatever happens to appear through your lens.

Consider a picture of a field that shows a barn on the right side. Without a balancing element, all the interest in the photograph is on the right, there's nothing remaining to look at, so the shot is less interesting than it could be. The composition would be much more balanced if the photographer were to capture something on either the lower or upper left side, such as a tractor, a tree, or even a cloud. The key is to provide multiple elements that will make the viewer more interested in your photograph.

You may need to make changes to your shot, shooting technique, or post-processing technique in order to correctly balance the elements in a photograph. Some tips include cropping your composition, altering your shooting angle, zooming in, or moving one of the elements in your photo, if possible.

TYPES OF BALANCE

There are many ways in which to achieve balance in a photograph, namely:
Light versus dark Use a white/light area to balance a black/ area.
Color Areas of bright color can be balanced with neutral colors.
Texture Balance small, heavily textured objects with larger, plainer objects.
Shape Irregularly shaped objects can be balanced out with larger, less detailed objects.
Size Balance a large object with a smaller one on the opposite side of the image.

Break the Rule:
Creating unstable compositions

Balancing elements can be challenging to achieve, as it involves a lot of forethought into a composition, and if you are unable to change the composition it may mean that you don't get the shot you want at all. Fortunately, you will find that in many cases it's easy enough to change your viewpoint enough to add balance to your photograph.

Sometimes the lack of balance—or even carefully composing your images so they are un-balanced on purpose, can make a composition more dynamic and edgy. Doubly so if the subject of your photo deals with unbalance, such as poverty/greed, power/helplessness, or happiness/grief. Using imbalance in these cases can, at times, increase the power of your shot and helps evoke an emotional response in your viewer.

The next time you are taking a shot, consider whether it is in balance. Start with your focal point and work out from there. Could you add something opposite the focal point to improve balance, or is it better off without it? Balance is a fun concept to play with, and so is creating unbalanced photos.

Below *Whenever you use the rule of thirds, you create an "unstable" composition. Giving this incredible building some room to breathe, it draws your eye to the building itself.*

The Rule:
Keep your focal point in focus

Nothing is worse than finding that the most important part of your photograph is blurry once you've made it back to your editing suite at home. More than any other characteristic of a photograph, badly focused images scream "amateur." If you're not getting your photos in focus, you are doing it all wrong! You absolutely, positively have to get your photos in focus.

While the autofocus on your camera should, in most cases, provide accurate focus most of the time, it can have difficulty when you are dealing with narrow depths of field, or in scenes where there may be many possible focus points to choose from. In these cases you may want to switch to manual focus by using the selector on your lens, or at the very least set a manual autofocus point so you know your camera is focusing on the correct part of the scene.

Shooting with a medium aperture buys you some leeway when it comes to focusing—in other words, a photo shot at $f/8.0$ that is slightly out of focus will still appear sharp. When you are working with very wide apertures, however, you lose that safety blanket, and you have to spend a lot more time and concentration making absolutely sure that your photos are pin sharp.

By keeping your subject in sharp focus you are ensuring that viewers understand what the your main subject is, which helps to keep the "message" of your composition intact. Placing the most important part of your composition in sharp focus in relation to its surroundings can also help to strengthen your image overall and make it the most obvious part of your photo—an important tactic if you are dealing with many objects in your shot and want to ensure that viewers understand what your focal point or subject is.

Above *Even if you're taking shots in which most of your model is in silhouette, you need to pay extra attention to the focus—if the silhouette's outline isn't sharp, you may as well not bother.*

Right *Taking a portrait? The eyes have to be in focus—every time. Even if the subject is wearing sunglasses, get them in focus!*

Break the Rule:
Throw focus to the wind

Focus is one of the things that is non-negotiable; if your photo's main subject isn't in focus, or if your portrait subject doesn't have their eyes in focus, you have a completely ruined photo on your hands. Or do you?

To understand when you can choose not to have your subject in focus, we have to look at why we've said that your photos have to be in focus. The main reason is that people are turned off by photos that aren't in focus. This is because it's very hard to relate to something that isn't crisp and easy to look at. However, this very disassociation can be used as a photographic effect. If you are telling a story about emotions that fit the theme, such as disassociation, depression, or the emotion of "not fitting in," choosing to have your photographs focused in ways that people don't expect can strengthen, rather than weaken, their impact.

Above *In some circumstances, the out-of-focus areas of the photo (known as "bokeh") are actually more attractive than the subject itself. This photo is a great example; the hot sauce bottle is pretty—but it's the background that makes this image worthwhile.*

There are more conventional techniques that call for alternative focusing approaches as well. With a Lensbaby lens, for example, you can choose to use selective focus that throws most of your image out of focus. If you're using a tilt/shift lens, you can "use" the unusual plane of focus afforded by those specialty lenses to create "miniature" effects, where your scene appears as if it has been photographed as part of a scale model world. In portraiture, you can use so-called soft-focus lenses or other diffraction techniques to give people and their surroundings an ethereal glow. Using pantyhose material stretched across the lens, or using a special soft-focus filter can help soften the features of somebody's face, which gives your shot a pleasing, somewhat dreamy effect.

Finally, shooting at night or a scene with lots of small light sources (such as in a city, or your Christmas tree with its lights illuminated) with a lens that has a beautiful "bokeh" can produce beautiful effects; the out-of-focus light blobs can give gorgeous effects.

Left *I could have taken this photo with the model's face in focus—but is that really what this photo is about?*

The Rule:

Get your models to act natural

Do you know why kids make such excellent subjects? Because they are always themselves. At virtually any point in time you can aim a camera at a kid and get a natural smile that could light up a room. This is why ensuring that portraits and photos of your subjects are as natural as possible is so important.

Successful portraits hinge entirely on the expression and body language of your model—and natural body language is the key to achieving beautiful, natural-looking portraits.

While acting naturally may seem like an easy thing for a model to achieve, in reality it can be very difficult. Most people have a hidden anxiety when it comes to photography, so your job as a photographer is to do your best to help calm their nerves and bring out their natural personality. But how? Below are a few tips.

Give them something to hold We all tend to show our nervousness or anxiety by fidgeting with our hands, which can result in distractions within a composition. So help your model out by putting something in their hands to distract them from fidgeting. Some ideas include flowers, an instrument, or even a pet.

Above *Some subjects scream out for a "natural" look, such as a mother-and-baby shot.*

Right and opposite *A pair of sunglasses and an old-fashioned twin reflex camera was all it took to add a spark of "life" and interactivity to this shoot!*

Don't wait While you may be tempted to wait a few minutes to let your model settle in, don't. You're likely to increase their anxiety while they wait for you to start. Instead, talk to them while you take your first round of test shots and help them get used to getting their picture taken.

Let them sit It's a lot easier to relax in a seated position versus standing, so make sure you bring a chair or stool to your shoot, or provide somewhere that your model can settle.

Help with distraction You will likely get more natural shots when your subject is thinking about something else, so help them by providing a distraction. Anything, from starting a conversation to letting them explore their surroundings can help to settle their nerves and create natural expressions. If you are working with two or more people you can let them interact with each other and see what kinds of natural expressions reveal themselves.

ACTING NATURAL

Some people seem to be completely incapable of acting naturally in front of a camera. It's not their fault. it is, indeed, very difficult to act natural on command. You'll occasionally find people who are unable to let themselves be photographed without looking completely goofy in the progress. The solution might be to take lots of photos. Get them to do something (read a book, play a video game, play with their child, or even do the dishes), and start taking photos. Eventually, they'll forget about you, and you'll start getting natural photographs. It's cheating, of course, but who cares? As long as you manage to get the photos you want . . .

Break the Rule:
Go over the top

Sometimes, glamorous, over the top photography is just the thing you need to create a stunning, memorable composition. Lots of makeup, fancy clothes, and a fantastic, yet slightly unnatural expression can create photos that evoke a variety of emotions—from fear to lust, or from happiness to extreme sadness.

For these types of photographs you really need to work to get your subject out of their shell, assuming they aren't professional models. It can help to have a narrative to help them connect with the expression you want them to convey, for instance, "you've just won the lottery" or "you found your spouse in bed with someone else" etc.

Natural expressions can be difficult for those who are very nervous around cameras so, occasionally, having the model convey extreme emotional expression can help get the model out of their shell. Have fun with it by seeing just how much of a range of emotions you can get your model to convincingly display. Then when they're on a break from that activity you can shoot a series of natural expressions as well.

Below, opposite top, and opposite bottom *There's no point in not having a bit of fun with portraiture: be brazen, break all the rules, and make a statement—an approach that suits these subjects very well!*

What's Next?

You've covered a lot of ground in this chapter, so take some time to let these concepts sink in and take hold. Once you start applying basic, yet powerful concepts such as the rule of thirds to your photographs you will see a drastic increase in the quality of your compositions, guaranteed. While this means you will need to spend more time thinking about your photos before you take them, it is well worth the time and effort taken to practice these techniques.

Just as with the last chapter, it can help to take a few notes about the rules you have learned here, so you can refer to them when you are out on a shoot. You do not have to incorporate every single rule into every single photograph, but by being aware of the rules and how they affect a composition you can certainly take advantage of opportunities to improve your shots.

Once you are ready you can continue on to the next section for some advanced tips on improving your photos and finding great shots.

5 Photography Concepts

There is more to photography than just rules; there are also things that you need to consider every time you are getting ready to shoot—such as where you are going and what you are bringing with you. Additionally, what settings you choose to use during your shoot can play an important role in ensuring that you get fabulous photos. The accessories you choose to use also affect your ability to get the "right" shot. Tripods, flash, and other camera accessories will give you more flexibility when shooting, but also require more room in your equipment bag, as well as a larger budget for purchase. As a photographer it's up to you to decide whether or not such accessories will give you more shooting options or will simply weigh you down.

Let's take a closer look at some of the "truths" of photography, and see if we can't dig a little deeper to find out what you need to know to take your photography to the next level.

Left *A great photo is a combination of many things—and everything has to come together as it does here to tell a good story!*

The Rule:
Plan your shoot

If you look at the photos in a fashion magazine, you can't help but be impressed by the incredible quality and high production values of the shots. None of that is a coincidence—for a single high-end fashion shoot, there will be several days worth of planning. Big photo shoots are not unlike film productions these days; there will be a production staff, equipment has to be hired, locations have to be found, and so on.

I'm not saying you have to break open the piggybank to get good photos, but there can be no denying that a strong vision combined with planning your shoots in some detail is a proven way to get great photographs.

Thinking about where, when, and who/what you are shooting lets you pack the right equipment, so you are ready when you arrive. The following tips may help.

Body If you have more than one camera, you're going to have to make a choice. Which one do you bring, or do you take both? Some photographers like to have several cameras on a shoot, already set up for different shots; one for wide shots, perhaps, and another with a longer lens, ready to go for up-close shots. This kind of choice is likely to depend on the type of shooting you are planning to do, and whether you will have time to change lenses during the shoot. Also, if you are traveling it can help to have a compact or EVIL camera for those times when you don't want to lug around your heavier SLR camera.

Below *Carefully planned lighting is crucial to get the results you want—without planning the lighting carefully, I would never have been able to create this photo.*

Lenses Carrying more than one lens means you'll need a bag that can handle your extra equipment. It also means thinking about which lenses you are likely to require for your shots. Do you need fast lenses (higher maximum aperture), telephoto lenses, portrait-style lenses, or something else? Most likely, you'll have one or two favorites that you prefer to shoot with.

Flash If you are planning to shoot in the dark, in partial or full shade, or simply like to have alternative lighting options, then you'll need at least one flash, if not a few. For multiple flashes you'll need some method of mounting the flashes, like stands or bungee cords.

Accessories There are, of course, about a million different accessories that you could plan to carry around with you. Fortunately, most photographers find that they stick to a few essentials, such as flash diffusers, tripods, white and gray cards, and light meters. Once you've delved into the world of photography you'll quickly realize what works for you, and what doesn't. Also, don't forget a spare battery and memory cards for long shooting sessions!

Above *When I was making a trip to an aquarium recently, I did my research to find out what kind of lighting situations I could expect. The research helped me choose the right lenses and accessories to bring, resulting in some strong, highly effective shots.*

There's a lot more to planning a photo shoot than equipment, though. Location shoots require some planning, too. Do you need permission to do the photo shoot you are planning? If it's an outdoor location, what happens if it starts raining?

Another thing worth considering in advance is what you want to get out of the shoot. Are you planning to use the photos for something in particular? If so, what are the criteria you need to fulfill so you can use the photo? Perhaps you're shooting a magazine cover. Most magazines are in portrait format, so that might impact how you plan your shots. However, if your photo will be used inside the magazine, they might decide to use the shot spanning two pages side by side (known as a DPS or double-page spread), in which case you're back with a landscape shot.

I've found that sketching out what my perfect shot would be helps me realize it when the day of the photo shoot rolls around.

Break the Rule:
Go ad-hoc

Planning is all well and good, but if you've ever had to arrange something at the very last moment, you will know that you sometimes get fantastic results precisely because you've had to think on your feet and make a series of snap decisions on the spot.

Photographers have very different personal preferences when it comes to preparing for a shoot, which usually evolve from many years of experience and observation. For some, it may not be worth the time or effort to think about every conceivable scenario that may require camera equipment. For others, it may be just a matter of instinctively knowing what equipment they need without having to consciously think about it.

As mentioned, you'll likely have a preference for the type of photography you like to shoot (wildlife, sports, portrait, etc.) and that's how your camera will be set up the majority of the time. As long as your battery is charged, the memory card is in, and the lens is attached there's not much else you need to think about—just go for it. There's a special thrill that comes with doing a photo shoot without any planning—the spontaneity and life that gets injected into the shots as a result is often visible in the photos, which, in turn makes them better.

No matter how much you plan ahead, even carefully planned photography requires a certain amount of thinking on your feet and rolling with the punches. You can't realistically expect your subjects or scene to perfectly co-operate at all times, and there are always unexpected elements that come a-knocking. How to deal with unplanned events is something that comes with experience, but don't forget that there's always an opportunity to stop what you're doing and start over. If you realize your photo session is moving in the wrong direction, take a quick break, and do it all over again.

Left *Some portrait sessions work because they're completely unplanned, impulsive, and spontaneous. You can usually tell from the results—and the models have a lot more fun with it, too!*

Above *Heading to a location without knowing what you'll find is half the fun— thinking on your feet and solving problems as they occur are great challenges that add to the photo shoot.*

The Rule:
Traveling for wildlife photography

Wildlife photography is an incredible hobby, and a photo safari is easily one of the most inspirational things you can do as a photographer. You haven't really lived unless you've heard the thrill in a tracker's voice when he says something like "We're getting closer to the rhino!" Photographers start fidgeting with their gear, the blood pressure and pulse raises, and if you get everything right, your photos will lock down amazing memories of an unforgettable trip.

Whether your trip takes you to rainforests in South America, the wild game reserves in Africa, the incredible expanses of wildlife-filled jungle in Asia, or perhaps even the underwater photography paradises of Belize, you're in for an adventure of photographically epic proportions.

The advantage of shooting wildlife is that when you've exhausted all the species in a certain area all you have to do is travel onward to a new location to a whole new set of families of critters! Birds, bugs, four-legged creatures—they are all waiting to be captured on camera.

TAKE THE PLUNGE

Planning a safari tour is a lot of work, and will cost a fair bit of money, but the truth is that you can get more memorable photographs in a wildlife reserve in an afternoon that you can capture in a year in your local forest. It's an investment for sure, but like all investments, it just might pay off!

Left *Photographing kittens at home is all well and good—but for the truly memorable wildlife shots, like this rhino at sunset—you have to travel further afield.*

Right *Experiencing the migration of the wildebeest is an unforgettable experience—and having photos to show for it is even better!*

Below *A wildlife safari is basically a first-class ticket to photos worthy of hanging on your walls. It isn't cheap but, like the subject of this shot, it is truly magnificent.*

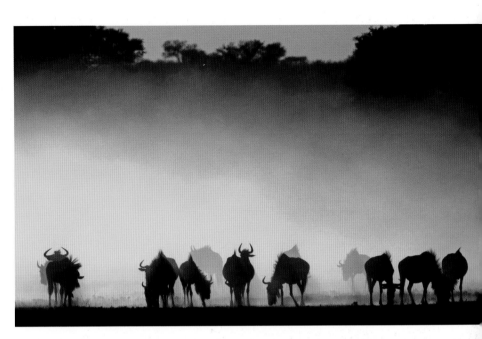

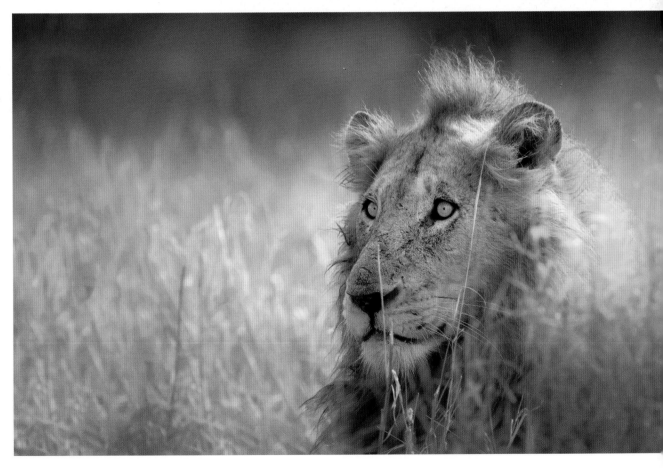

Break the Rule:
Local wildlife

It's probably true that you're more likely to capture amazing images of lions and tigers and bears (oh my!) in more exotic parts of the world, but wherever you live, you're probably going to find at least some wildlife close to home. Whether you have hummingbirds, pigeons, foxes, or just your pet bunny or the neighbor's dogs, photographing animals, even non-exotic ones, is a satisfactory experience.

Place a birdfeeder in your garden to lure the animals closer to you, or head to a local butterfly farm or the zoo. There are plenty of opportunities to practice your photography skills locally.

Even if you aren't planning any wildlife photography, it's great practice to keep your camera to hand and on the ready when you're

Above *A nearby safari park can provide some great photo opportunities—limiting the background also gives the impression the picture was taken farther afield.*

Left *A bit of patience and stalking in your local forest could give some rather lovely results. Stay still and keep quiet for optimum results.*

Below *If getting close to them isn't working, maybe you can attract them to you? Try having some feed with you—this cock was much less shy when food was on offer.*

out on walks or drives, in case you run into some wildlife while out on the road. Deer, coyotes, birds of prey, even raccoons and skunks can make excellent photographs. Plus, you don't have to wait around in a field or bush for them to show up. Rural areas can also have lots offairly accessible farm animals. Sure, they aren't wildebeest or lions, but they still let you practice taking shots!

Local zoos, aquariums, and other wildlife centers also offer a chance to get close to wildlife without having to stage encounters or wait in the wings. It's probably best to visit these places during less busy times, so you don't have to fight the crowds to get good shots. Also, carefully read any conditions found on the back of your ticket as these may restrict you from posting them online or selling your photos.

Below and bottom *Pets can make great photo subjects, but like photographing children, it can be difficult to get them to keep still. Try waiting until they're sleeping to practice your skills.*

The Rule:
Use correct white balance

Finding the correct white balance for your photos is important. Without white balance that is at least roughly correct, you'll probably discover that your photos, no matter how lovely the scene looked when you took the photo, come out looking distinctly "off."

Below *White balancing can be incredibly difficult, especially when you are dealing with multiple light sources, like in this photo. Nonetheless, keeping things as neutral as possible is crucial for genuine-looking images.*

As humans, we don't tend to notice how the color temperature of different light sources affects the things we look at. The explanation as to why is pretty simple: our brain makes the adjustment for us. Sadly, cameras aren't quite as clever as the human brain, which means that, whilst they often get it right, they're also prone to getting things wrong from time to time. A photograph that's poorly white balanced makes all the other colors in the scene appear off—usually either too "warm" (too red) or too "cold" (too blue).

In the scenarios in which you are not getting the right white balance, making the necessary corrections is as easy as taking a photo of a white piece of paper (or investing in some very affordable white and gray cards) and selecting the photo you took as your preferred white-balance setting. Essentially, you are telling the camera "this is the how white/gray appears in this light, so make the necessary adjustments to make it look right"—easy!

If you are dealing with several light sources of different color temperatures (such as sunlight and flash, or flash and incandescent light) it can be difficult to get the correct white balance on camera at times. However, you can always choose the White Balance Shift Bracketing mode to take several shots with different white balance levels, or take your shots in Raw mode and make additional adjustments in post-processing when you will have more time to play around with the various levels.

Using the correct white balance is imperative if you are interested in depicting the correct colors, regardless of the color temperature of the light illuminating the shot. This can be important for journalistic photography, sports photography, portraiture, and any other type of photography in which you want your shots to depict the color of your scene as closely as possible.

Opposite *Getting the white-balance as neutral as possible makes the sky pop and the flowers really jump out of the photo in this photograph.*

Break the Rule:
Bring on the off-white balance

What is "correct" white balance anyway? To your camera this means making white look white and gray look gray, which, in turn, balances all the other colors of the spectrum. The only thing is, sometimes the "correct" white balance just isn't right for your scene, and by using the "wrong" white balance you can get a much more interesting result.

One common example is portrait photography. Depending on the light source and the surrounding scene your subject can appear pale white or have a bluish tinge to their skin, even if you are using a manual white-balance setting. So is this the "correct" white-balance

Above *Sunrises are a great opportunity for white balance trickery. In this photo, I made the white balance much "colder" than it originally was. The result is the beautiful blue-to-orange gradation in the sky. In real life, the sunset was just plain old red—and not nearly as visually appealing (see below).*

Right *The original version of the image above—pretty, but not as beautiful as the one with "creative" white balance.*

setting? Unless you are taking a mug shot, likely not. However, by using a white balance mode such as the shade setting you can get richer, warmer tones that make your portrait look more appealing.

So what do you choose? The objectively and scientifically "correct" white balance, or the one that makes your photo look better? It depends on how much of a photographic purist you want to be, of course, but I'm more than happy to admit that if a photo looks better when I use the "wrong" white balance, then I'm proud to be deliciously wrong, and end up with prettier photographs to boot!

TIP

To preview white balance on your camera, try switching to different modes as you shoot. If you make sure your camera is set to "Raw+JPEG," your JPEG files will have the white balance applied, but if you later decide you made a silly decision, you can use the Raw files to change your mind.

Above *Wonky white balance adds some additional attitude to this shot.*

Right *By applying a slightly warmer white balance to this photo, the water looks prettier and the surfer looks more tanned and healthy—a far better result!*

The Rule:
Use blurred backgrounds

Honestly, there's nothing as stunning as a photo with a perfectly focused subject against an artistically blurred background. There are so many reasons why this type of shot works so well, but the main one is that is gives your focal point top billing, so the viewer's eyes cannot help but be drawn toward it.

Creating blurred backgrounds can also give us a challenge by making us control the amount of background blur so objects in the background are visible and discernable, but don't distract from the rest of the image. You can have some fun with this as well; place your subjects in front of contrasting backgrounds to enhance the interest in a photo. For example, place a kitten in front of a blurred sleeping dog behind, or a child against a backdrop of a shack or hospital wing. As we discussed in an earlier chapter, backgrounds don't just have to be "in the background"—they can also provide the viewer with more of the context to a photograph.

If the background does not enhance the story behind the image then it may be best to blur it so it is not discernable. For example, a person in front of a bunch of posters on a wall may be interesting if the posters have something to do with the picture, but otherwise it may be a distracting element that should be blurred completely so it doesn't distract the viewer.

Above *By isolating this glass of cider against the background, it leaps out of the photo.*

Above *A shallow depth of field ensures that your eyes don't stray from the subject. Because there's nothing to look at in the background, the model gets all the attention.*

Below *By using a blurred background, you can use the colors of the surroundings as context, without having to worry about your viewers being distracted.*

> ### TIP
> *If you are having difficulty blurring backgrounds you should use a larger aperture, increase the distance between your subject and the background, and decrease the distance between you and your subject.*

Break the Rule:
Keep everything beautifully sharp

I f you're doing a location shoot and you have gone through all the trouble of getting there, why should you sabotage all your hard work by stopping down your lens and let your background vanish into a smudgy blur of bokeh? Depending on your scene and subject, including the background can help to enhance the interest of your photo, and provide some context as to where it is being shot and what is happening.

If the focus of your photo is a person, then yes, including a background can distract a bit from your focal point. However, limited depth of field is only one of many things you have in your photographic toolbox by now; we've talked about

leading lines, contrast, and the golden triangle rule. If you can incorporate these techniques and workto ensure that your subject still stands out as a focal point then, by all means, keep your background in focus, provided that it adds something to the scene.

Sometimes the background is your subject, such as when photographing walls, windows, houses, doors, and landscapes, so obviously for these types of photos you want to have everything in the background in focus. It can help to start by identifying the most interesting part of the background (your focal point) and work from there to create an interesting composition.

Left *There's nothing to be gained from limiting your depth of field in some photos, as in this lovely landscape shot, so embrace the small aperture, and keep it all beautifully sharp.*

Below *It would have been easy to drop part of this photo out of focus, but it thrives on the mystery and the playfulness, and part of that is that you can see everything, and yet not enough.*

The Rule:
Always use a tripod

When I first started learning about photography, the two pieces of advice given to me were "get a tripod" and "use it all the time." There may have been something to that; we were shooting mostly with very slow (ISO 25) black-and-white film, and the shutter speeds we had to use were very long indeed. There is a lot you can learn from shooting with a tripod. It allows you to explore the realm of long shutter speeds and low-light photography while keeping your shots super-sharp. It also comes in handy at events where you are going to be taking shots over an extended period of time and don't want to hold your camera all day long.

You may have heard of the inverse rule for when you should use a tripod. Anytime you are shooting at speeds slower than the inverse focal length of your lens (i.e. for a 50mm lens this is 1/50 of a second, or for a 300mm lens this is 1/300 of a second) you are at risk of introducing blur into your photos, as it is difficult for the human body to remain perfectly still for that length of time without some slight movement of the camera. However, there's a lot to be said for using a tripod even when you're nowhere near breaking that rule. Any amount of camera shake will introduce a little bit of blur into your images, so a tripod is a sure-fire way of getting sharper photographs.

A tripod ensures that, when you are taking photos using longer shutter speeds, the camera remains perfectly still. If you haven't yet explored the awesome world of sunsets, sunrises, and night-time photography, a tripod will give you many more hours during these times for taking excellent photos. Plus, it also lets you take photos of yourself alone or in a group by activating your camera's timer, so you are no longer restricted to one side of the camera.

In wildlife photography a tripod allows you to set up a shot so you have everything ready for when your subject comes hopping (or lumbering) along. Paired with a remote trigger, you can sit comfortably and trigger the shot when your subject is in place. For sports photography a tripod (or, if you have to move around quickly, a monopod) helps you to create consistent shots, and saves your neck and shoulders from a lot of strain, particularly if you are using a heavy telephoto lens.

Finally, when you are shooting macro shots or are in your studio, using a tripod helps to keep your hands free so you can adjust your composition, lighting, or model in order to create more interesting shots. A good tripod costs relatively little, so there's no excuse, really. Get a tripod. Use it all the time.

Right *For longer exposures at night, like this one, you'll need the additional support of a tripod.*

Left *For still life photographs, use a tripod to ensure that everything comes out tack-sharp.*

Right *Tripods are especially necessary in macro photography as you can't hold the camera still enough to capture shots like this.*

Break the Rule:
Going legless

Right *In the studio, you have the option to use a tripod, but personally, I prefer to increase my shutter speed and turn the lights up instead. It's tricky enough to get a good connection with your model when there's a camera between your face and hers; a tripod just makes it worse.*

Below *If you want to introduce camera blur for creative effect, you're definitely going to need to handhold your camera. This shot wouldn't work out if the camera was locked to a tripod.*

Above *Tripods are a curse to spontaneous shooting. If you want to keep up with these little guys, you're not going to get far with a tripod.*

There are many great reasons for using a tripod, but personally, I prefer to go legless whenever possible. Cheap tripods can be very heavy. Very light tripods can be very expensive. And any tripod takes up space. Worse—tripods need to be adjusted between shots, which practically kills off the spontaneity of anything you're trying to achieve. Besides, a tripod is not a great choice for shooting locations and events that require you to move in and around people/objects quickly; documentary-style photography, street photography, and most portraiture can be done perfectly fine without relying on a three-legged lump of metal.

There are many tools designed to help you avoid having to use a tripod. Many newer, higher-end lenses come with built-in Image Stabilization (IS) or Vibration Reduction (VR) which help you take photographs with longer shutters speeds without having to worry about blur. Some cameras come with Image Stabilization built into the camera body, which is a bonus as it means that all your lenses are then image stabilized.

Unless you want a longer shutter speed for some reason (i.e. to blur movement), you can often get as good a shot by handholding your camera and making adjustments to the aperture or ISO level in order to use a faster shutter speed. With practice, you can also train yourself to stay still for longer shots without creating blur in your photos. Without a tripod you can create more interesting compositions using a variety of angles as well and will have more flexibility with changing your shots on the fly.

The Rule:
Keep foregrounds in focus

The goal of photography is storytelling. The "words" in your story are the components of your composition, and your main subject is the punch line of the story. Thus, it is important to keep the foreground in sharp focus whenever possible, particularly with landscapes in which the foreground helps to set the scene. This way, your composition can tell the story from beginning to end.

Foregrounds can provide important clues as to where in the world the picture was taken, the season, even the era (for antique photos), so by including the foreground you are enhancing the interest of the photo and giving the viewer more to look at, therefore creating a more dynamic composition.

Having the foreground in focus is also important if you are taking a photo of a series of similar items, such as a selection of flowers at a market. From front to back, having the foreground in focus lets the viewer's eye travel naturally from the beginning (bottom) of the photo to the natural focal point of your photograph.

Whatever is closest to the camera needs to be in focus; otherwise, you end up with a confusing composition—if you have anything close to you your image that's not in focus, consider moving or recomposing your shot; nothing good will come of blurry foregrounds!

Above *It goes without saying perhaps, but if your foreground isn't in focus, you're not doing your job properly!*

Left *What a waste! This could have been such a beautiful photo, but then I ruined it all by failing to focus properly.*

Break the Rule:
Playing with multi-layered images

Portraits are the one main exception to the keeping-foregrounds-in-focus rule. With a portrait, your job is to attract attention to the face and eyes. By including foreground elements in a portrait you may be distracting the viewer's eye from the subject, so it's worth being quite careful with this effect.

While most of the time you will merely get in close enough to fill the frame with the subject's face, sometimes you can include some elements in the foreground that are out of focus, to add more interest to the shot. For instance, your subject can be in focus between blurry blades of grass or tree branches, or even his or her own hands. If you were photographing a seamstress working on a sewing machine, you could consider including in the foreground of the image the top of a sewing machine, with colorful spools visible, perhaps.

The main effect of having several "depths" visible in your photos is that your shot takes on a more three-dimensional quality.

Above *By using this technique of shooting past some figurines while focusing on others, an impression of voyeurism is created, giving the shot a documentary feel.*

Right *Sometimes, you'll want to introduce a feeling of depth to your photos by having several "layers" of focus and out-of-focus. In this shot, the palm trees in the foreground are sharp, but the clouds and moon behind it are out of focus. Glorious!*

TIP

When you are trying to work in multiple "layers" of a photo, keep a very sharp eye on your focus—it's easy to make mistakes that can't be corrected later, so make sure you spend a bit of extra time to get it right!

The Rule:
Avoid camera shake

Above *An incredibly long shutter speed allowed me to capture the Golden Gate Bridge in San Francisco from Alcatraz Island. If I hadn't brought my tripod to stabilize this picture, there's no way it would have worked out.*

Nothing is worse than having a great composition set up, only to find out that camera shake has made your shot blurry, particularly if you don't notice the blur until after you download your photos onto a computer. Unfortunately, camera shake is a common occurrence with longer exposures, particularly when you are using a telephoto lens.

A tripod will allow you to use much longer shutter speeds with a very low chance of introducing camera shake, as will also let you keep your hands free for making notes and adjustments. Of course, if you are taking photos of people or other moving objects, you still have to consider the possibility of subject motion blur.

Remember that you can always adjust the ISO and aperture in order to create the appropriate exposure when increasing the shutter speed, so your photos come out perfect. You can also try using wider-angle lenses if possible; camera shake will still be an issue, of course, but it's less visible if you use a wide-angle lens, because the movements of your hands are less magnified. This will help you hold your camera still for longer exposures without having to deal with camera shake.

Left *This photo was taken with a pretty slow shutter speed (1/15 of a second). To capture shots like this, be extremely careful to hold the camera still, or you lose the effect you are going for.*

Break the Rule:

Give your camera a good rattle

There are more than a few ways to use your camera artistically so as to create stunning compositions by embracing long exposures and camera shake, so don't discard the notion of camera shake just yet. In fact, sometimes a bit of camera movement can be a good thing!

Panning shots are a fun way of using longer exposures along with a moving camera in order to create arresting photographs. For this type of shot to work you need to be able to make a smooth panning motion from side to side, following the object you are shooting. Cars, bicyclists, and runners are a common panning subjects. It'll take a bit of experimentation to get right, but the idea is to use a moderately long shutter speed—1/15 of a second tends to be a good starting point. Keep your subject in the frame, and twist your upper body as your subject comes flying past to keep it in the same place in your frame for the duration of the exposure. The effect is that your subject appears to be standing more or less still, whilst the background is blurred by the motion of your camera. Fantastic!

Another interesting technique is to play with your focal length while taking a picture. You'll likely need a tripod for this, unless you are good at holding the camera steady. During a long shot (around a second or more) zoom your lens out— the result will depend on what you are shooting, but common shots for this technique include backlit trees and other subjects with backlit light. The "aura" effect can make for beautiful pictures and is certainly worth a try.

Above *By moving the camera on purpose whilst using a long exposure, you can produce some beautiful, dynamic photos.*

Left *Combine camera movement and a long shutter speed with a flash, to get an awesome part-frozen-in-time, part motion-blurred photo. Use Av or manual mode on your camera to achieve this effect.*

The Rule:
Freezing motion with fast shutter speeds

Freeze! That's what you should be thinking when you are taking photos of moving subjects. But how fast a shutter speed do you need to freeze motion? The answer depends on several factors, including how fast the subject is moving, and where it is moving from/to. Below are some suggestions.

Type of Movement	Recommended Shutter Speed (in seconds)
Person walking	1/125
Person jogging	1/250
Breaking waves/surf	1/125–1/250
Rain drops	1/60–1/125
Horse jumping	1/800–1/1000
Children moving	1/250–1/1000 (depends on how fast)
Waterfalls	1/1000 or faster
Birds flying	1/1000 or faster
Racing cars	1/500 or faster
Dog running (toward camera)	1/250 or faster
Drop of water (or other liquid)	1/1000 or faster

Keep in mind that the closer you are to your subject, the faster a shutter speed you'll need to capture action. Also, subjects moving across the composition (left to right or vice versa) will need a faster shutter speed to freeze movement than a subject that is moving toward or away from the camera. Don't worry—once you get used to shooting moving subjects, choosing a shutter speed will become more intuitive, but for now try using the chart on this page to get started.

Freezing movement allows the viewer to get a clear picture of what your subject is doing—whether it's playing basketball, surfing, or running through the grass. By freezing the shot you can keep everything in focus so the elements of the shot describe what is happening, such as a slam-dunk in front of a roaring crowd or hanging ten in front of a tropical sunset. Motion freeze keeps everything in perspective, so your photo can clearly illustrate the scene and subject.

Motion freeze can also create some interesting compositions—particularly when water is involved. Splashing water, waves, sprinklers, raindrops, the list is endless. Anytime you are around water see whether you can "freeze" it. You will love the results!

Right *Lizards are notoriously fast, and the only way to freeze this one in place was to use a really fast shutter speed of 1/2000.*

Above *A lightning-fast 1/1000 shutter speed stops this skateboarder in his tracks.*

Left *Freezing the wafting movements of smoke or steam is perfectly possible— but you do need a lot of light and a fast shutter speed.*

Above *Only by using a very fast shutter speed can you hope to capture the fine movements of water splashing out of a water glass.*

Break the Rule:
Let it flow

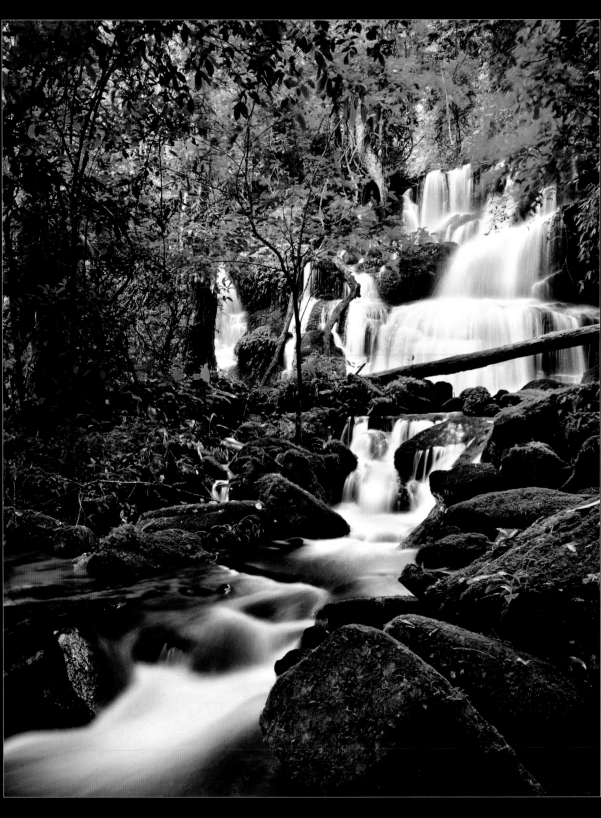

Freezing movement is fun, but there are two concerns. One is that in low-light situations it can be difficult to get a correct exposure with fast shutter speeds. The other is that freezing movement makes for a less dynamic shot than showing movement.

For example, consider a F1 race car frozen with the background perfectly captured, or the same car racing by (using a panning technique) with the background a blur of color. While one captures the scene, the other works to show just how fast the car is going.

Longer shutter speeds tend to blur movement (unless the photographer follows the movement, as above with panning technique) but also make for fun compositions. With the water shots mentioned earlier, taking longer shots creates a misting, flowing effect that makes beautiful shots, particularly with waterfalls, ocean surf, and rivers or streams.

Remember that if you want to keep the rest of your scene in perfect focus you will likely need a tripod, unless you are trying panning shots. The benefit of the longer shutter speeds is that you can work in lower-light situations and still produce amazing shots, even in the dark! You haven't explored the full realm of photographic possibilities until you shoot by star or moonlight (or even take shots of the stars/moon themselves!)

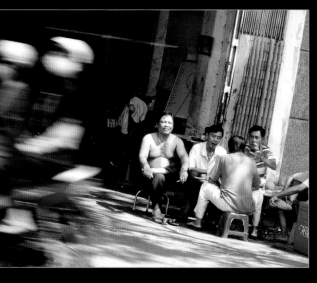

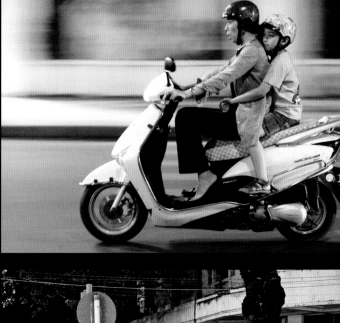

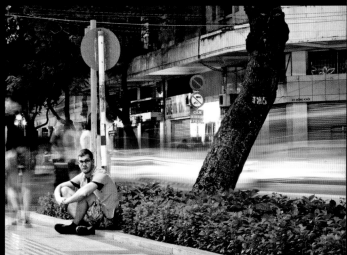

Opposite *Waterfalls are a classic subject for flowing photographs—use a long shutter speed to transform the individual droplets into streaks of flowing motion.*

Top right, top left, above right, and above left *There are many ways in which to introduce a feeling of flowing motion into your photographs by using motion blur—experiment to find the photos where it works best!*

The Rule:

Sharper is better

What is sharpness? In photography, sharpness is the quality of your photos that renders a clear image of your subject. Your photos will become sharper by:

- using high-quality photographic equipment
- sticking to the "sweet spot" of your lenses (they tend to be sharpest around two stops smaller than their largest aperture)
- ensuring you've focused your camera on what you want to photograph
- choosing a depth of field that keeps your subject crisply in focus
- avoiding motion blur in your subjects (choose a fast shutter speed)
- avoiding camera blur (by choosing a fast shutter speed and using a tripod).

So, sharp photos are clearer, in better focus, etc. The benefit of a sharp photo is that small details are much more discernable and the overall composition is more interesting to look at. However, getting your photos as sharp as possible can be a challenge at times.

In order to get sharp photos you primarily need the right aperture and shutter speed to get the appropriate depth of field in your photo, and have a fast enough shutter to freeze movement and prevent blur due to camera shake. It is also important to have very little noise in a sharp photo, so lower ISO sensitivity is preferred.

It's important to get to know your lenses and exactly what they are capable of. Many lenses are not as sharp when they are "maxed out"—i.e. are set to the smallest or largest

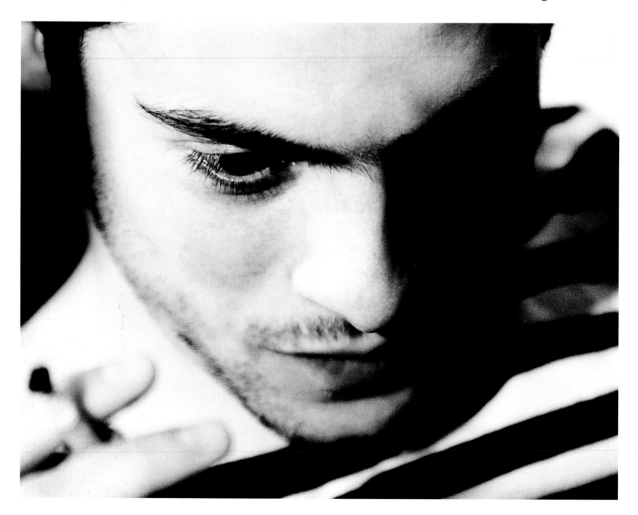

aperture, or are zoomed all the way in or out. By understanding at what point your lens is able to produce the sharpest photos you can ensure your compositions are as sharp as possible.

A few other factors affect sharpness, including how clean your equipment is. Ensure that the front and rear glass of your lenses are cleaned regularly, as well as any filters you use, to prevent a film from building up. Also remember that you can improve sharpness in post-processing, to a degree.

Opposite *Perfect focus on the model's eyes is what makes this picture so eye-catching.*

Right *Eyes. When you connect with them, it's almost as if you can look into someone's soul.*

Below *I'm dreadfully aware how silly I look here, but look how lovely and sharp the photo is! Good lighting, and a relatively large aperture made this self-portrait possible.*

THE IMPORTANCE OF EYES

Your eyes are the only tool you have that can determine if your composition is as sharp as it can be. That being said, many of us put off annual eye exams because we feel like our vision is "just fine." However, when it comes to photography you need to have 20/20 vision, particularly if you are manually focusing your camera, otherwise you may be disappointed with how your photos turn out.

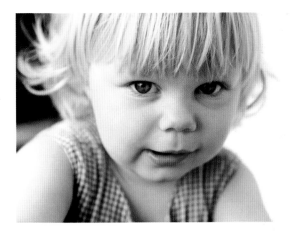

Break the Rule:
Embrace the blur

If the photo you are taking has a lot of detail that you want the viewer to see, then a sharp photo is great. You'll see a lot of sharp photos when it comes to macro photography and the like. But that doesn't mean that sharper is always better. Sometimes a little softness is just as nice.

Portrait photography is one area where perfect sharpness isn't always the best choice. Who wants to be able to count someone's pores, anyway? In this type of photography too much sharpness can be distracting, so it can be a good idea to back off a bit, or at the very least use a few post-processing tricks to eliminate distractions and make the portrait more appealing. However, you do want your focal point (usually the eyes) to be perfectly focused, so there is a very fine line here between too sharp and not sharp enough.

Other types of photography where sharpness is not important include photos where you are using blur to indicate motion, abstract photography, and using blurring to eliminate distracting elements from a composition. Remember that, regardless of the sharpness you choose, you still want to draw the viewer's eye toward the focal point, so sometimes leaving a single sharp element can create a very dynamic shot.

What's Next?

Now you almost know everything there is to know about taking great shots. You understand your camera, the various settings, and which lenses work best for particular shots. You also have a good grasp of the rules of photography and how they affect a photograph, as well as how breaking these rules can sometimes provide you with exceptional shots. So what's left?

The next chapter is going to cover one very important aspect of photography: lighting. Since photography is all about capturing light with a camera, a great photographer needs to know how to work with various types of light in order to get the appropriate exposure, create a mood, and take fantastic shots in all types of light—from full sun to full dark. So buckle up, because we aren't done learning yet!

Opposite top *In this image (which was perfectly focused before I edited it digitally), I was going for an old-photo look. It took me a long time to realize why I couldn't get the edits right, until I blurred it a little; when I did, it fell into place beautifully.*

Right *Some photos simply look better when the subject isn't tack-sharp. In this particular shot, the juxtaposition of cheap vodka and a blurry photo is not a coincidence— because the camera appears to be a bit inebriated as well, it helps to tell part of the story!*

Opposite *For some photos, you're going for impressionism rather than photo-realism. This sunset shot was made with a homemade pinhole lens; the blur really adds to the photograph, because it helps to capture the feeling of the color and movement, rather than the details of the subject. Does it matter that the details are missing? I don't think so!*

6 Lighting

Wouldn't it be nice if you always had picture-perfect lighting in every shot you ever take? It sure would, but sadly, that's very rarely the case when we're talking about photography. You'll very often find that you have too much light, too little light, light of the wrong color, light coming from the wrong direction, light that's too harsh or too fuzzy . . .

Photographers love to complain about this for a very simple reason: light is photography. Without light, there are no photos to be taken. Your camera has an exceptional ability to capture light and use it to create stunning compositions. All you need to do is learn how! By keeping a close eye on lighting conditions, you can ensure that you take full advantage of available light, and have an understanding of when you may need to bring along additional equipment (such as flash units or reflectors) in order to create more light when required.

You'll be unsurprised to learn that there are many rules surrounding light and lighting . . . let's take a closer look at some of them.

Left *Whether you go for natural lighting—as in this shot of a beautiful sunrise—or artificial, you'll find that the light is one of the most crucial things to get right. Bad lighting makes for bad photos.*

The Rule:
Keep the sun behind you

The sun is by far the most powerful and prevalent source of lighting you are going to encounter, so treat it with the respect it deserves! During the daytime, even on glum and overcast days, it usually delivers plenty of light. Ambient light from the sun, regardless of where it is in the sky, is enough to fully illuminate pretty much any subject, so it's important to note what the sun is doing and where it is located in relation to your subject when you are setting up your shots.

One primary rule of photographing with sunlight is to "keep the sun behind you." I'd like to modify that rule ever so slightly—to say as the photographer, stay between the sun and your subject. As long as the front of your subject is lit, you're heading in the right direction.

Photographing in sunlight works especially well late in the day; it gets a gorgeous, warm feel at these times. Known as the golden hour, this light gives your subjects a warmer skin tone, and creates less harsh shadows. Of course, early morning sunlight is much the same; it's just usually more difficult to get people out of bed to pose for photos at that time. If at all possible, try to schedule portrait shots during golden hour, as this will give you the best results.

Above *If the sun had come from behind the model in this street photo, her face would have been hidden in shadow—not nearly as good a shot.*

Left *On a slightly overcast day, it can be hard to see where the sun is coming from. On the bright side, it makes for beautiful soft lighting, like that visible in this portrait of a friend.*

Break the Rule:
Shoot into the sun

Eventually, you will encounter a situation in which you can't put the sun behind you, either due to the placement of the subject or a preference as to background (such as a view or seascape). In these cases it's best to be prepared so you are still able to expose your subject correctly while incorporating the sun behind them.

The biggest challenge with having your subject between you and the sun is that the sun is an enormous ball of fire in the sky. It's rather bright, and it's using all its fiery power to illuminate the "wrong" side of your subject. If you still decide to take photos this way, you do have a couple of options available to you . . . The first option is to illuminate your subject's face somehow. The two most common ways of doing this is either to reflect the sunlight back on them, or by using "fill flash" to brighten their face a little.

The second option is to choose to overexpose the background; there may still be enough light in your scene to light the face of your subject properly—but, obviously, you'll end up with a grossly overexposed background. For some photos, this can look beautiful, but it depends on your subject and the rest of your scene.

The final option is to decide to expose for the background. This causes silhouettes, which isn't the greatest approach to portraits, perhaps, but can give you some beautiful mood photos, especially in sunsets, for example.

Above top Sunsets are another obvious situation in which you'd aim to shoot into the sun—with glorious results.

Above In this photo, the lighting is coming nearly directly from above— but because light is being reflected off the buildings surrounding the subject, the shadows were not too harsh, and the photo came out well.

Left You can produce striking silhouettes by shooting into the sun, as in this shot.

The Rule:
If it's dark, use flash

Is it too dark to take photos? Hmm, that could be a problem. I wonder what this button does. Hey, will you look at that! A flash just popped right out of the camera! How rather marvelous.

It doesn't matter if you have a pop-up flash or a more advanced accessory flash unit; a lot of people will tell you not to use it, because it gives hideously unrealistic lighting. That's hogwash—if it's too dark to take photos with natural lighting, it makes sense to use the technology you have available to brighten your day.

Above *By placing a flash with a diffuser just off to the side of this DJ, the mood in this nearly pitch-dark nightclub shines through—and I had just enough light to capture the photo.*

Right *When taking photos in the studio, you get perfect control over your lighting. If you have that luxury, use it to its full effect.*

BOUNCING POP-UP FLASH

Even if you don't have an accessory flash, you can always "bounce" the flash on your camera via the ceiling. Use anything white or reflective at a 45° angle in front of your camera to reflect the light upward. Bear in mind that not all on-camera flashes are bright enough to use this trick, so be prepared to up the ISO setting on your camera if necessary.

Left *By using "bounce" flash, the light from this flash photo didn't come out too harshly, and some of the mood in the photo was retained.*

Flash technology is getting better all the time, but the flash built into your camera has a bit of a disadvantage, precisely because it is built into your camera. Its location means that the light from the pop-up flash comes from basically the same direction as your camera. It makes sense when you think about it: we are used to light sources that hang from the ceiling or hang in the sky high above us—not ones that come essentially from your own vantage point.

For this reason, if you have an off-camera flash available to you, it is often a better choice than the on-camera flash. By using an off-camera flash, you can remove the light source further away from your camera, which drastically improves the perception of the light. Alternatively, if you have an accessory flash, you can instead use the aimable flash head to "bounce" the flash light. To do this, aim your flash upward. The light will reflect (or "bounce") back from the ceiling. By doing this, you turn the entire ceiling into a light source, which has two benefits. A much bigger light source means softer light, and by changing the direction of the light to come from above, the light looks much more natural.

You also have to pay close attention to your white balance if you are combining flash and another light source, such as incandescent lighting or sunlight. Since the color temperature of either of these two light sources is very different from that of your flash you may have trouble balancing the color. The best solution in this scenario is to use gels (thin colored strips of plastic) to change the color of the light from your flash to match the other light sources.

WHAT'S A SLAVE?

If you are new to camera terminology then the term "slave flash" may mean nothing to you, but it's an important concept to those wishing to get the most ideal lighting conditions using flash. A slave flash is simply an off-camera flash that is controlled by the main camera flash (either your built-in flash or an additional flash unit). The flash created by the main camera flash, or master flash, triggers the slave flash at the same time. The benefit is that you can place the additional flash unit at a more appealing angle to your subject, as well as improve your lighting setup by using both flashes simultaneously.

For those really interested in photography with flash, you can add more slave units to create full lighting studios at much less cost. If you are looking to improve your low-light photography, then learning to use slave flash units can be just the ticket.

Right *A flash with a blue gel on it lighting up the background creates a beautiful moody background.*

Break the Rule:
Shooting in the dark

If you set your camera to fully automatic, it'll assume it knows best, and often turn your flash on for you. That's not always the right call, however. If you can take advantage of the ambient light available for your shot, give it a try.

Don't get me wrong—flashes come in very handy in cases where there is just not enough light or when you need more light in order to use a faster shutter speed. But it's important not to depend on it too much or you may miss the opportunity to create deeply dynamic and dramatic compositions.

Remember that shutter speed is your best buddy in low-light situations. Unless you need to freeze movement in its tracks, you can pretty much go as slow as you want in order to correctly expose your shot. With a long enough shutter speed you can even take excellent shots at night without the need for flash, even if your scene is only lit by the light from the moon and stars. Don't forget your tripod for these long shots, or at least look for a stable surface nearby to set your camera on.

When approaching a shot you need to ask yourself the following question: "Do I really need to use flash?" In many instances you may find that by increasing the size of your aperture, increasing ISO sensitivity, or choosing a longer shutter speed (or a combination of the above) you can get the right exposure without resorting to flash.

Above right *Taking a photo like this will require a long exposure, a lot of patience, a sturdy tripod and, yes, your flash turned off.*

Opposite *My camera kept demanding I turn the flash on;only by overruling it and turning the flash off manually was I able to capture the beautiful, ghostly atmosphere of this scene.*

Right *Shooting at night gives some beautiful opportunities, including taking photos of the starts. In this shot, the exposure was nearly an hour, so the stars appear to be zooming through the sky.*

The Rule:
Higher contrast makes better photos

Photographs tend to look more alive when there's a lot of contrast, so understanding how it works can help your photos leap off the page. So, what is contrast? To explain the concept, it's easiest to reach for black-and-white photography. Here, contrast describes the difference between the lightest parts of your photo and the darkest. More difference equals more contrast, and makes for a more dynamic shot.

You can implement high-contrast subjects in your images; as an example: what would look more visually interesting—a gray kitten against a gray background, or a white kitten against a black background? The one with more contrast will naturally draw the viewer's eye. However, contrast is also an effect of post-processing—we'll talk about this in greater depth in Chapter 7.

Left *A huge difference between the brights and the darks in this photo is what makes it so compelling. Note that it's still relatively softly lit—the transition between highlights and shadows is nice and even.*

Below *Even though landscape photography traditionally is all about soft and even tones, you can break those rules for some high-impact images, especially when it comes to urban landscapes.*

Above *High contrast is great for adding a spot of drama to your shots.*

Introducing contrasting colors to your compositions can be a bigger challenge, but there are many ways in which to do it. You can, again, choose tonal contrast as in a black-and-white photo (picture a red marble amongst light pink marbles) or you can put contrasting colors against each other using the color wheel. Colors from opposite sides of the color wheel have the most amount of contrast—for example, red ornaments on a green Christmas tree, or an orange sun above a blue sea. Color contrast is a very easy way in which to make a composition more interesting, and also draws more attention to your focal point when it contrasts with its surroundings.

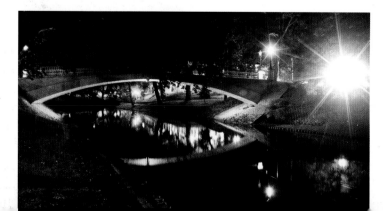

Break the Rule:
Low-contrast compositions

Snowy or foggy landscapes tend to be lower contrast naturally, and make scenes seem beautiful and calm.

A lot of new photographers use contrast as a crutch when taking or editing their photos. I know it well; I too have a huge library of photos taken when I first started out, all with enormous contrast. In retrospect, that was a mistake. High contrast is not a cruise-control button for awesome shots. Sure, you can reach for the contrast slider to add impact to your photographs, but there's a lot more to good photography than that.

Lower-contrast photos can contain a world of subtlety, mood, and innocence. High-key photography, for example, is a separate style of photography that deliberately reaches for the precise opposite of high-contrast imagery.

By choosing scenes that lend themselves well to low-key photography, you're opening yourself up to dreamy photographs, embracing the subtle, ethereal quality of clouds and fine dustings of snow; somehow, in the process of choosing to move away from the firm, known quality of high-contrast imagery, we've crossed over into a world of the perishable, the fragile, and the beauty that follows from something that isn't long for this world. Embrace the low-contrast world. Go on, you know you want to.

Above top *Low-contrast photos are a completely different photography style from high-contrast shots.*

Above and left *Snowy or foggy landscapes tend to be lower contrast naturally. The lower contrast is what makes the scenes feel so tranquil and breathtaking.*

The Rule:
Use color to create mood

Color! Who doesn't love color? From the light pastel whisks remaining after a sun has lazily sunk into the ocean to the deep and bold solids of fresh paint, color is all around us. As a photographer, you can incorporate the mood of color to evoke an emotional response in your viewer.

Do you know what mood different colors evoke? While it tends to depend a lot on culture, here are some common color associations.

●	**Black**	*Authority, power, style, evil*
○	**White**	*Innocence, purity, sterility*
●	**Red**	*Love, lust, anger*
●	**Blue**	*Peace, tranquility, depression, cold*
●	**Green**	*Nature, calmness, freshness, relaxation, fertility, wealth*
○	**Yellow**	*Cheerfulness, optimism*
●	**Purple**	*Royalty, luxury, sophistication, romance, femininity*
●	**Brown**	*Genuineness, wistfulness, earthiness*

With the meanings fresh in your mind, it's not a huge leap of logic to start applying some of those colors to the way you work with your photography. Use them to your advantage by creating a mood. For example, a child out in the rain wearing yellow boots, yellow raincoat, and carrying a yellow umbrella would appear to be having a good time, while the same child wearing all black would not evoke the same type of mood, would they?

Remember that color means different things to different people, so you may not always accomplish what you set out to do when trying to incorporate mood and color. Red can mean love to some, success to others, and rage to a third group, so by using red to illuminate mood you may be sending the wrong message to parts of your audience. You will need to use other elements such as objects or facial expressions to lead your viewers to which mood you are portraying.

There's no rule stating that you have to use a particular color for a particular mood, although it may help to consult the list on the previous page if you want to create a certain response. For example, any bright color is going to generally evoke a more positive mood than dark or dreary colors. It's all about what is available to you when you are out and about.

It can also be fun to have your shot be all about color, such as a group of colored pencils, a brightly painted wall and door, spilled paint, or even a group of different colored cars. Color is fun, so have fun with it!

All *You'll find that powerful colors will have a huge impact on the feel of a photo. To discover just how much, try turning your photos into black and white images to see what the composition loses.*

Break the Rule:
Mixed messages & muted colors

For all our talk of colors—whether bright and cheerful, muted and downbeat, vibrant or partially desaturated—it cannot be denied that photography has a long history of having no colors at all. At the dawn of the artform it was a technical necessity, but even after color photography became more common (in these digital days, pure black and white is only found in distant corners of medical and scientific photography) many photographers are still reaching for the abstraction and beauty that can spring from an absence of color.

First of all, some photos just do better when there is a lack of color. Black and white photography can be used to create powerful images that resonate with an audience. The same goes for sepia-toned or other monochromatic photographs. Sometimes by removing color (or making it equal across the board), you can help viewers focus on what's important about your composition, rather than have them get caught up in the colors.

Color isn't always something you can control, either, although with a good photo-editing program there is certainly a lot you can accomplish after a shot is taken. Don't worry if you can't get the "perfect" combination of color in a photograph. It is much more important to focus on the content of your photo than the color. After all, you're not going to abandon a shot simply because the car in the photo is blue instead of red, are you? Likely not, unless you are shooting with a specific purpose in mind. Often, the color in a shot is not a determining factor in making a good shot good, it is simply another tool you can use to make a good shot better.

Take a step back and look at your composition. Does it need color to communicate a mood or feeling? Does adding color improve the shot, or does it distract from the message? By considering

these questions you can decide whether your photo needs more of a particular color, or is doing just fine the way it is. Remember that you can use other indicators to portray mood, such as posture, facial expression, or the subject of your composition.

Opposite This image is nearly devoid of color—in fact, it only has brown, shades of brown, black, and white. But that's in part why it's such a powerful image.

Right This particular photo works so well precisely because it doesn't seem to fit with preconceived notions of photography or color.

Below The soft, partially desaturated colors in this shot help give it a particular feel—one of innocence, perhaps, and a slightly old-fashioned look.

The Rule:
White balance your photos

Whether someone who views your photo understands white balance or not, they will certainly notice if the white balance of a composition is wrong. Incorrect white balance levels can have a dramatic effect on photos, particularly when your subject is a person as it can add an unnatural tinge to the skin tone that can't be ignored: badly balanced photos look "off."

White balance is important, so if you don't already know how to use the different white-balance settings, as well as how to set a custom white balance, it's time to get started. Make no mistake: you will most certainly need white balance to make high-impact photographs, and in some circumstances, just leaving your camera in automatic mode is not good enough.

Having a correct white balance is particularly important when working with multiple light sources, as your camera has a harder time automatically correcting white balance with different light temperatures. Setting a correct white balance can be as easy as taking a shot of a white piece of paper and hitting a button on your camera to tell it that the paper should be used to set the correct white balance. It takes less than a minute and ensures that your photos come out correctly.

Another instance where setting white balance comes in handy is when you are taking photos in the snow, as your camera will find it difficult to deal with so much white. Without setting the white balance you may end up with blue-cast photos that won't properly depict the scene. Although in most cases you may be able to make corrections to white balance in post-processing, it's much easier to ensure that your photos are correctly balanced in the first place.

Above, below, and opposite *In portraiture, landscapes, and food photography, perfect white-balancing is a must. If your photos don't look realistic, your audience is turned off and will move on to the next photo.*

Break the Rule:
Throwing white balance to the wind

If you're shooting in Raw, you don't need to worry too much about white balancing; the Raw file stores all the information captured by the imaging chip, which means that you can adjust your white balance after the fact.

Even so, I'm not going to enforce an unbreakable rule that says you may never, ever "misbalance" your photographs on purpose. Quite the contrary, in fact: sometimes, photos that are a little bit "warmer" or "colder" than the camera or the Special White Balance Taskforce prescribes can work very well. Portraits, for example, can look more together when you apply a smidge of extra warmth—it makes people look friendlier, and the warmer colors give an impression of, well, warmth.

The opposite is also true. Barren landscapes, and scenes of despair, can look positively delicious with a slightly "too-cold" white balance. Experiment—and if the "wrong" white balance gives you a "right" photograph, don't hesitate to use it—if it looks right, it can't be wrong! Follow your instincts and go where your creative flow takes you. That's true not only for this rule, by the way, but for every rule anybody ever tries to impose on you in the world of photography— if it is "wrong," but gives a beautiful result, it ain't wrong.

Below *In landscapes, turning up the color temperature a little, as I did here, can create beautiful, warm photos that are more appealing than their neutral brethren.*

Above *Portraiture can benefit from some extra warmth. It makes people look healthier, more tanned, and friendlier, too.*

What's Next?

We've spent a fair few chapters discussing how to take photos, how to compose them, and what settings on your camera, lens, and accessories work best for particular situations. Hopefully you have learned a lot and are starting to see some improvement in your compositions. Now it's time to put the camera down and explore an entirely different realm of photography—digital editing. Also referred to as post processing, these are the tips, tricks, and tools that allow you to make corrections to your shots to improve the color, hue, white balance, and even to edit parts of your photo to make for a more pleasing overall composition.

This doesn't mean that you can abandon all or most of the rules learned thus far and simply hope for the best with digital editing. It merely gives you another set of tools to help you make the most dynamic and interesting photos possible. By combining the rules of photography with some rules of post-processing you can ensure that you have the best chance of ending up with some stunning shots.

7

The Rules of the Digital Darkroom

Few things polarize people more than post-production in photography, and it's often extremely challenging to cut through the vast amount of advice available both on- and offline. In this chapter, we're going to take a closer look at the rules and advice about what happens once you're safely back at home, with your memory card in a card reader, a cup of tea or a beer in your hands, and a few thousand photographs to edit.

The Rule:

Use Adobe Photoshop

Photoshop has been around since the dawn of digital graphics. Today, the software package is used almost across every industry that has any kind of graphical output. If you look at anything that has been designed at any point, I'm willing to bet that Photoshop was involved in its creation in one way or another. Magazines, graphical layouts, packaging design, product design, 3D rendered objects; even Hollywood movies often reach out to Photoshop for at least part of their post-production.

A graphical powerhouse, Photoshop is well known for having half a dozen ways of achieving nearly any effect you can think of applying to a photograph (just off the top of my head, I can think of more than 20 different ways of turning a color photo into a black-and-white one). It's tremendously powerful, and whilst it is true that it can be a little tricky to learn, there is no denying that if you are a serious photographer who wants to fully embrace the possibilities awarded by digital post-production (or the "digital darkroom" as it is often called), you can't get around Photoshop.

There are a few different versions out there. The two most applicable to photo editing are the Creative Suite (CS) edition, and the Elements edition. Adobe launches new versions of Photoshop CS and Photoshop Elements at regular intervals, and each version has more features, more power, and more creative options. The CS version is the "full" version of Photoshop and is aimed at professional graphic artists. It has every bell and whistle you could possibly dream of, and is immensely powerful. It should come as no surprise, then, that it is also wickedly expensive. For the price of a license of Photoshop CS, you could easily pick up an entry-level SLR camera, or a pretty fancy compact camera.

The Elements edition of Photoshop is built on the same engine that powers Photoshop, but strips out a lot of features. Adobe argues that stripping away a significant number of features makes the software easier to learn. I'm not convinced that they have gotten the "easy to learn" part down quite yet, but Elements has one huge advantage over the CS edition—it is much cheaper, offers

more features than most novices use, and also has a large amount of handholding and tutorials built into the software (and available as videos online) to get you started.

There are quite a few alternatives available to Photoshop, but in my opinion, for photo editing, this rule is here for a reason. Choose Photoshop.

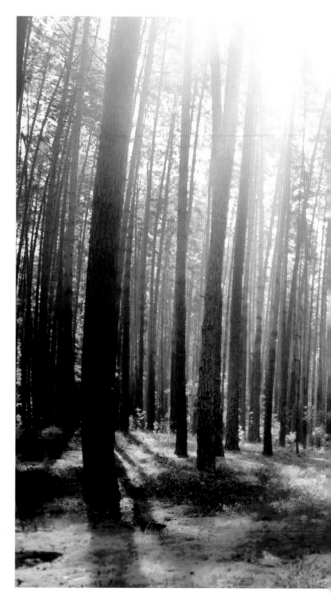

WHAT ABOUT ALL THE OTHERS?

The Creative Suite edition is, without doubt, the most all-encompassing tool available for photo editing; if the edits you are thinking of doing cannot be done in Photoshop, then there is a very genuine possibility that the edits you have dreamed up cannot be done at all.

As powerful as Powershop CS and Elements are, however, it is worth keeping in mind that the digital workflow you use in your digital darkroom is about more than just editing your photographs—so before you mortgage your firstborn to buy a copy of Photoshop CS, flip the page to find out what else is available.

Below *By increasing the saturation and cleaning up some minor blemishes on the forest floor in this image, you create a much more striking photograph overall.*

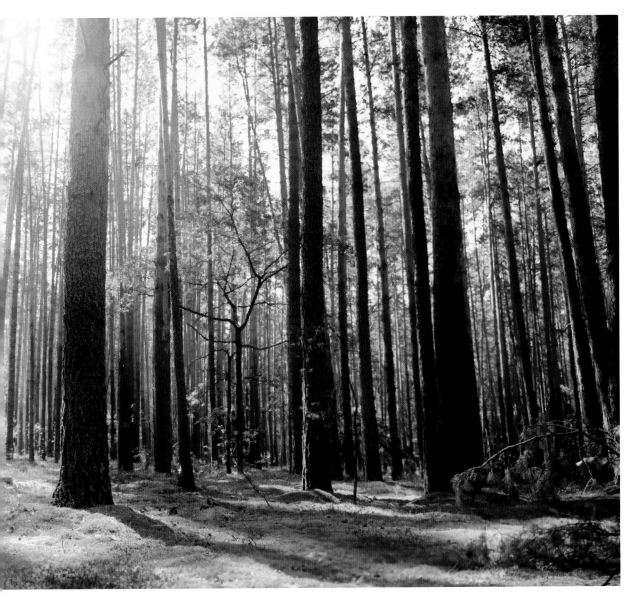

Break the Rule:
Photoshop alternatives

It cannot be argued: if all you want to do is to edit your photographs, Photoshop is the best tool out there. However, there's a lot more to the digital darkroom than just making individual photographs look pretty; there are some adjustments that are frequently made, including white-balance adjustments, crop, color saturation, and the odd minor corrections here and there. In addition, having to open up every single photo you've taken at a 1000-photo shoot

in Photoshop would take ages. I know this all too well, because that used to be the only way you could work.

These days, there are two alternative software packages that have some extremely compelling features for photographers: Adobe Lightroom and Apple Aperture. Instead of focusing on giving you the tools to make advanced edits to one individual photograph, these packages have other strengths. For example, they allow you to browse and

organize large libraries of photographs, make edits and adjustments to large numbers of photographs at once, and sort, select, and choose what photos you are going to work with going forward.

They also have powerful search functionalities. You can search based on when the photo was taken, for example, based on its ISO, what camera it was taken with, or even what lens it was taken with. You can combine search criteria as well, so you can "build" a search to show all photos in your library taken at higher than ISO3200 and with shutter speeds of longer than one second, taken between June 2002 and August 2004. It sounds like magic, but those are precisely the type of searches you can do; and if you frequently need to find specific photographs, those search tools are absolutely phenomenal. A lot of the specific examples in this book are found by using precisely these kinds of searches.

Of course, both Aperture and Lightroom have a lot of editing features, too. Most of them are "global edits"—or edits that apply to the whole image at once, such as white balance, crop, color edits, noise reduction, and creative filters. Both packages have limited spot-editing tools (edits that apply to a small portion of a photo) as well, which are great for removing a spot from someone's face or taking away a chocolate wrapper from an otherwise pristine beach, but not that great if you want to do more in-depth editing on your images.

Left *The Lightroom user interface can be a little daunting, but once you become used to it, you won't know how you ever did without it.*

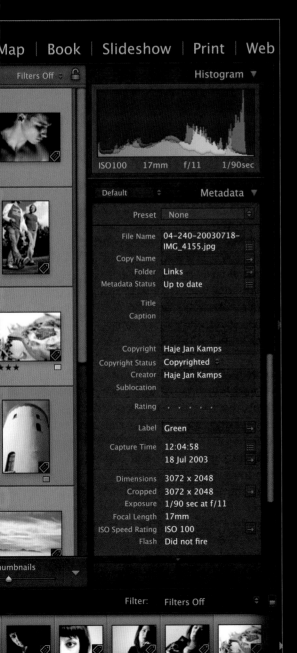

BUT WHAT ABOUT FREE OPTIONS?

There are quite a few Photoshop alternatives that are low-cost or free, and some of them are getting pretty good, too. Search online for GIMP for the current front-runner. Personally, I look into Photoshop alternatives every few months to keep abreast of what's available. There is great creativity and some fantastic efforts out there, but I invariably go running back to Photoshop again—it turns out that there's a reason for why it's the best-selling software package—it's the best!

The Rule:

Always take back-ups

It's as if there were a rule for photographers about never, ever, ever taking back-ups.

"But Haje, what if something happens to your house? What if someone steals your computer? What if your hard drive fails?", I hear you cry, in terror.

The depressing truth is that many amateur photographers—and a distressing number of professionals—treat never taking backups as if it's a rule. Almost without exception, photographers take back-ups of their work too rarely, in haphazard ways, or store them in ways that aren't useful for backup purposes.

You probably see where I am going with this: this is one of the rules I want you to break. Always. Take back-ups in a way that covers the following, and you should be okay:

- Always make sure you have a back-up of anything you are working on. That means that you should never delete photographs from your memory card until you have copied them to two different locations on your computer—preferably an external drive and the internal drive on your computer.

- Keep a set of back-ups off-site. It's no good having all your photos on your internal hard drive, an external drive, and on DVDs, if one house-fire or burglary loses you all of your back-ups at one fell swoop.

- Try to recover a back-up every now and again: There's nothing worse than thinking you have a back-up, discovering you need to recover from a back-up, only to realize that your back-up strategy didn't work, after all, or that you were backing up the wrong files somehow. It's more common than you'd think. I've heard of photographers who accidentally took back-ups of low-resolution library of preview images, instead of the full-resolution original Raw files.

Opposite *Going, going, gone. A terrible tragedy, but remember that all your equipment can be replaced. The same cannot be said for your photographs—so always make sure you have a solid set of back-ups of your most valuable pictures!*

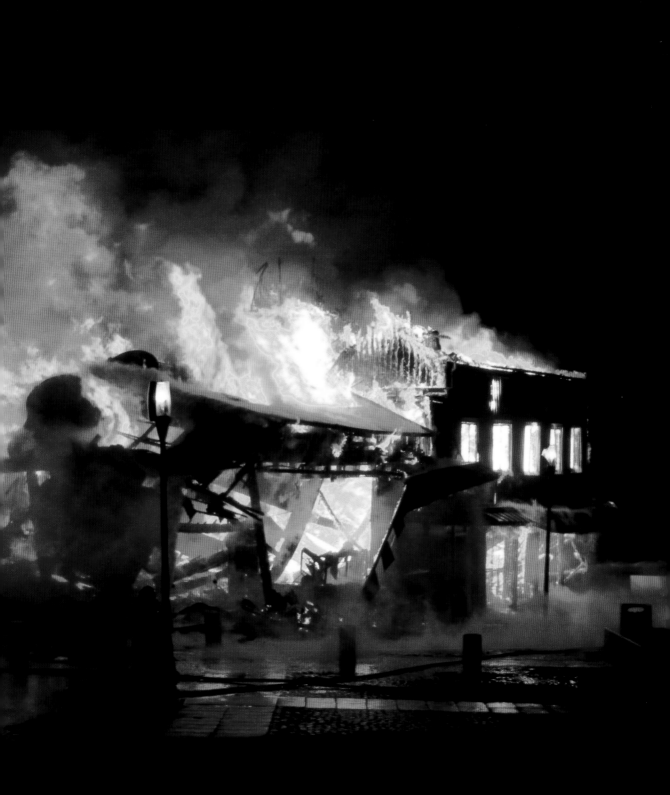

The Rule:
Always shoot in Raw

The files captured by your camera will be either JPEG, TIFF, or Raw. Each of them have some advantages and disadvantages, but if photo quality is your prime concern, there is no competition: the Raw file format are the only files that store all the data captured by the imaging chip inside your camera, and it follows that this gives you the most flexibility for making further adjustments in post-production.

Raw files contain vastly more information than JPEG and TIFF files, and they are better for the future, too. In fact, Raw files are likely to get better as time goes on. Sound improbable? Well, what is happening is that home computers are getting more powerful, and the algorithms used by advanced software packages are getting better and better all the time. This means that five years from now, a photograph taken today can be "updated" to the most recent process, which conceivably results in a photo that has less noise, more sharpness and more accurate colors than is possible with today's technology.

Above *It was my own clumsy fault, but when I took this photo, it came out way too dark. If I hadn't taken this shot in Raw, it would have been beyond saving.*

Below *The rescued version actually turned out quite nicely—thanks to Raw.*

Break the Rule:
Not shooting in Raw

After I've spent so much space in this book arguing for Raw, how come I have the audacity to argue against it as well?

The only major downside to Raw is its file size—on my camera, Raw files are about five times larger than JPEGs of the very same scene. There are a few different consequences to this file-size issue, and some photographers will run into these issues more often than others.

Shooting with Raw files is slower. This is true for all SLR cameras, even really, really fast ones. The problem is that your camera has a "buffer" built in, where your photos are stored temporarily whilst they are processed and then written to the memory card. When the buffer is full, the camera will prevent you from taking any additional photographs. If you are in the middle of photographing something where you have to take many photos, and quickly, this is a huge disadvantage. Sports and events photography are two situations in which you may find yourself running out of buffer space. Using the fastest memory cards available alleviates this problem a little, but it doesn't eliminate it altogether. If you feel you risk missing a shot because you run into your buffer limit, switch to JPEG. It's always better to get a photo that is a little lower in quality than to run the risk of missing it altogether.

Raw files are only of benefit if you intend to edit your photos. If you are working to a tight deadline, for example, if you are photographing an event and you know you will never, ever edit the photos in the future, Raw will only slow you down. If you are sure you'll never edit the photos, then you may as well shoot in JPEG. However, personally, I'd never use this as a reason. I never know 100% that I will never edit a photo in the future—but you might be different.

Raw is slower to process. If you are working in situations in which you are taking large numbers of photos that need to be processed, such as taking time lapse photos that you aren't going to edit much, but instead will string together and turn into a video, Raw may be slowing you down. Put simply, you just don't need the extra quality, and having to import, process, resize, and export all the Raw photos into film frames would take ages, and for no good reason. Consider using JPEG in such circumstances, too.

Below *With sports photography, getting the shot in the first place may be more important to you than being able to edit it as much later. If so, JPEG may be the best way to go.*

The Rule:

Stick to standard aspect ratios

All *Nearly all of my photos are cropped to 3:2 aspect ratio.*

We're quite used to looking at photos that are a particular, fixed aspect ratio. Common aspect ratios are 3:2 (the typical "film frame" aspect ratio we've been using in photography for a very long time), 4:3 (old TVs use this aspect ratio), 16:9 (wide-screen movies tend to be in this aspect ratio), and 1:1 (square photos).

There is a lot to be said for sticking to these; there are many psychological reasons as to why we react better to photographs in these aspect ratios. Familiarity, a sense of ease, and the golden triangle rule (see page 97) all come into it.

Subjectively, I think that photos in 3:2 aspect ratio simply look better. If I were to flick through my Flickr stream, I see that the vast majority of my photos stick to this resolution. Strange, perhaps, when the 3:2 restriction could be argued to be an outdated constraint. In the digital age, you can get your photos printed in almost any aspect ratio, and online, nobody cares what the

aspect ratio of your images is. It'll show up on-screen regardless.

I find that sticking to 3:2 helps photos keep their natural look; it can help to maintain the illusion of photos that came out of the camera with a perfect crop (even though I think nearly all of my photos have had their actual crop adjusted after the fact).

It's a matter of taste, of course, but overall, I think it is beneficial to stick to the established basics. It helps to ground and frame your photography in a way that encourages people to relate to the pictures as photographs, which is a quick and easy stepping stone to helping your viewers to be in the right frame of mind to appreciate them.

Break the Rule:
Getting creative with aspect ratios

Sticking to established aspect ratios? Pah, don't be such a square! We don't live in the middle ages anymore, and if you want to go crazy, then knock yourself out! Panoramic photographs are a great example. The ability to stitch a series of pictures together into a single image completely shatters the need for using the same old squares to limit your photos. Go wild, explore, go crazy!

All *There is no real right and wrong way to shape your images—go nuts!*

The Rule:
Keep saturation looking natural

Above *Keeping tones and saturation neutral is crucial. In this image, the original photo came out with too much color, so I decided to dial it back a little. By reducing some of the saturation, the model looks more natural.*

The digital darkroom gives you a lot of flexibility to edit your photos, not least when it comes to the possibilities of turning colors into something they weren't at the time you took the photo.

The quickest way to ruin the subtle, potentially intense mood in a photograph is to lose neutrality. In photography, your goal is, in part, to evoke strong emotions in your audience. One of the ways in which to do that is to make your photographs as true to life as possible. If it looks as if your viewers could step into the scene, they are more likely to feel as if what they are looking at is real and approachable. Keeping things neutral is a key element of that approachability.

In portraiture, especially, maintaining a natural feel is a great way of making your subjects seem real.

Right *This photo provides an excellent example of how different a photograph can look based on how much saturation you add or remove to it, ranging from completely desaturated (black and white) in picture 1, via partially desaturated, neutral, and over-saturated (picture 4). Each of these photos has its own emotional impact, and tells a very different story. In my opinion, in this case, keeping things natural-looking (photo 3) is the best approach.*

Break the Rule:
Natural is for wimps—let saturation be your badge of pride

Natural? Neutral? Who ever said that photography was meant to be documentary in nature? If you look at movies, they'll almost always use a particular color palette, and some movies—*Moulin Rouge* being an excellent example—use colors as an all-out assault on the visual senses. Muted is well and good if you're a documentary photographer, but if your goal is to encourage your viewers to stick your photos in a frame and display them with pride on their walls, you have to find a way to make them stand out.

There's no point in leaving your photos quivering under a rock like a shy bunny rabbit. Be bold! Be unusual! Reach for that saturation slider, and turn it to 11!

Above *Nature is full of beautiful colors, and by increasing their saturation, we can tease out high-impact photos.*

Above and right *There's a time and a place for subtlety, but portraiture isn't it—people are bold, adventurous and vibrant, so shouldn't your photos reflect that?*

The Rule:
Converting your photos to black & white

Turning your photos into black and white is not a magic bullet for better photos but, in many cases, you'll it can add a touch of class to your shots that would otherwise be missed.

Before you flick off the color switch in your software package, it's a good idea to think about what converting a photograph to black and white actually does to your images. To evaluate that, start from the other end of that question. Consider what color adds to the photo. Some pictures simply don't work in black and white, because the beauty of the image relies heavily on color. If that's the case, no amount of editing or tweaking can make it an appealing black-and-white picture.

The opposite is also true, of course. There are photos that don't work in color, because the colors in your photograph clash horribly, or because they draw attention to an area in the photograph that competes with the intended focus. Converting such an image to black and white will leave you with a completely different image; one that could potentially look very good indeed!

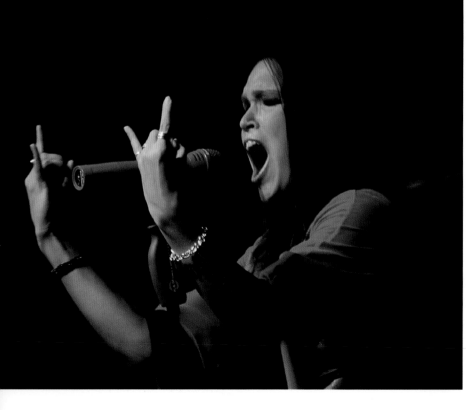

Above *Black and white helps people focus on the interplay between light and dark—and the texture of what you're photographing. This wooden figurine looked vastly better in black and white than in color.*

Left *When I work in concert photography, I'm often exasperated by how terrible the lighting is on stage. With this shot, black and white saves the day yet again.*

Opposite *In this photo, the color of the lighting meant it was impossible to white-balance. That's no good reason to get rid of it, though; a cheeky conversion to black and white was all it took to make it a gorgeous shot.*

Above *In some genres of photography, such as this infra-red photo, black and white is the only way to show off your photos.*

WHAT IS IN A BLACK-AND-WHITE IMAGE?

When you strip colors away, you are left with a very different photograph indeed—all you are left with are shades of gray (contrast) and textures. Monochromatic photographs remove one dimension (that of color), but can add an incredible amount of depth that is missed in color photographs. Experiment with your favorite images in both color and black and white to get a feel for the difference.

Break the Rule:

Creatively converting your photos to black & white

Of course, there's more to turning a color image into a black-and-white one than just taking a button labeled "color" and turning it to "off." Photographs consist of a huge amount of different colors, and by using creative methods of turning your images into black and white, you can achieve drastically different effects.

Lightroom and Aperture (see pages 170–71) both come with a series of black-and-white conversions built in. Personally, I use them frequently, because they're a great way of getting a feel for whether a particular image would work in black and white at all. You can also try different conversion settings to see what works best. If you like the results of the preset you've chosen, you can use it as-is; alternatively, you can tweak one of the settings to your liking. Best of all—if you find a particular black-and-white conversion that works well for you, you can save it, and use it as one of your own presets in the future.

Left *Black and white isn't just black and white—it's a combination of all the color channels that are available. You can see the huge differences you have available to you in these versions of the same image. Picture 1 uses the same amount of data from each of the color channels. Picture 2 is based mostly on the green channel. Pictures 3 and 4 are based on the blue and red channels respectively.*

HSL / Color / B&W ▼

Black & White Mix

Red		+50
Orange		+50
Yellow		+50
Green		−50
Aqua		−50
Blue		−50
Purple		+50
Magenta		+50
		Auto

The Rule:
Spot-editing your photographs

The strict view

Photography purists will tell you that you should never spot-edit your photographs. What they mean by that is that you shouldn't do any editing that applies only to a small portion of your photograph. It's a great point. There's no reason why you should do any spot-editing on your photos.

If you're having to remove a candy wrapper from the ground in one of your photographs, it means you made a mistake earlier on in the process: you should have picked it up before you took the photo. Similarly, if you're removing a sign from a wall, or a blemish from someone's skin, your photos are no longer photographs: they don't show the world as it is, but rather what you, the photographer, have turned it into. It's a slippery slope: if you remove anything from a photograph, it essentially makes you a liar. You don't want to be a liar, do you?

The moderate view

Another way to look at spot-editing is to see it as a way of achieving what could have been, but wasn't on the particular day you took your photos. Whereas a purist might decide to leave a candy-wrapper in a field, you might decide that it wasn't possible to pick up the candy wrapper at the time. Perhaps it was on the other side of a fence, or maybe it was floating in a lake. Obviously, the candy wrapper isn't part of the scene you are photographing, and if you had taken the photo a day before or a day later, the wrapper wouldn't be there. So yes, editing it out would be a lie, but it's a plausible lie: and after all, we're here to take great photos, aren't we?

The same applies to editing photos of people. You might have taken a portrait photo of somebody, but on the day you did the shoot, your model had a small scratch on their cheek after a minor disagreement with a kitten. Obviously, the cut will heal over time. Editing out the scratch in post-production would be similar to cleaning up the candy wrapper—it isn't a permanent feature of the person's face, so you could merrily remove it and you wouldn't be an outright liar.

If that very same model had moles, scars, birthmarks, freckles, wrinkles or other permanent features, you'd leave them there. Removing them would be akin to removing a fence-post from a landscape photo. It's not a wrapper that would have blown away by itself over time.

The laissez-faire view

Your goal is simple—create the most beautiful photographs you can, with all the tools you have available in your arsenal. The "truth" be damned! Landscapes and people look better when they have been retouched to look perfect, and the photos you're taking aren't the final result you're going for at all. Photos are the raw materials; the starting points for further editing. If you have a photo with a beautiful sky, another with a beautiful foreground, and a third where your model's arm looks a little bit better than in your original foreground, then so be it. Farewell accuracy, hello Franken-photo!

Ultimately, the only thing that matters is the print that goes on the wall. You're an artist, dammit, not an archivist!

> **TIP**
>
> *How you choose to do your editing is entirely up to you—and it also depends on your target audience. If you aspire to having your photos in* National Geographic, *for example, be aware that they allow very little (if any) editing. On the other hand, if you are aiming to be a magazine or fashion photographer, you'll often find that any photo you take is merely the starting point for an extensive amount of editing . . . try all approaches and see what you like best.*

Left *This is the original image, without any spot editing at all.*

Left *Here, the image has been edited according to the "moderate" approach to spot-editing.*

Left *This version of the image displays the no-holds-barred approach of the laissez-faire types.*